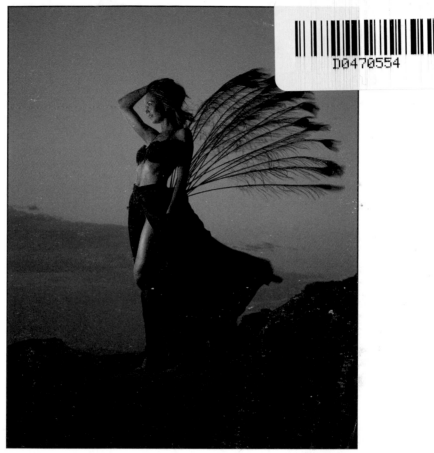

© Eddie Tapp

Studio & Location Lighting Secrets
for Digital Photographers

Rick Sammon and **Vered Kashlano**

WILEY

Wiley Publishing, Inc.

CALGARY PUBLIC LIBRARY

JAN -- 2010

D0470554

Studio and Location Lighting Secrets for Digital Photographers

Published by
Wiley Publishing, Inc.
10475 Crosspoint Boulevard
Indianapolis, IN 46256
www.wiley.com

Copyright © 2009 by Wiley Publishing, Inc., Indianapolis, Indiana

Published simultaneously in Canada

ISBN: 978-0-470-52125-0
Manufactured in the United States of America

10 9 8 7 6 5 4 3 2 1

No part of this publication may be reproduced, stored in a retrieval system or transmitted in any form or by any means, electronic, mechanical, photocopying, recording, scanning or otherwise, except as permitted under Sections 107 or 108 of the 1976 United States Copyright Act, without either the prior written permission of the Publisher, or authorization through payment of the appropriate per-copy fee to the Copyright Clearance Center, 222 Rosewood Drive, Danvers, MA 01923, (978) 750-8400, fax (978) 750-4744. Requests to the Publisher for permission should be addressed to the Legal Department, Wiley Publishing, Inc., 10475 Crosspoint Blvd., Indianapolis, IN 46256, (317) 572-3447, fax (317) 572-4355, or online at http://www.wiley.com/go/permissions.

Limit of Liability/Disclaimer of Warranty: The publisher and the author make no representations or warranties with respect to the accuracy or completeness of the contents of this work and specifically disclaim all warranties, including without limitation warranties of fitness for a particular purpose. No warranty may be created or extended by sales or promotional materials. The advice and strategies contained herein may not be suitable for every situation. This work is sold with the understanding that the publisher is not engaged in rendering legal, accounting, or other professional services. If professional assistance is required, the services of a competent professional person should be sought. Neither the publisher nor the author shall be liable for damages arising herefrom. The fact that an organization or Web site is referred to in this work as a citation and/or a potential source of further information does not mean that the author or the publisher endorses the information the organization or Web site may provide or recommendations it may make. Further, readers should be aware that Internet Web sites listed in this work may have changed or disappeared between when this work was written and when it is read.

For general information on our other products and services or to obtain technical support, please contact our Customer Care Department within the U.S. at (800) 762-2974, outside the U.S. at (317) 572-3993 or fax (317) 572-4002.

Wiley also publishes its books in a variety of electronic formats. Some content that appears in print may not be available in electronic books.

Library of Congress Control Number: 2009931750

Trademarks: Wiley and the Wiley Publishing logo are trademarks or registered trademarks of John Wiley and Sons, Inc. and/or its affiliates. All other trademarks are the property of their respective owners. Wiley Publishing, Inc. is not associated with any product or vendor mentioned in this book.

About the Authors

Rick Sammon

Rick Sammon has published 34 books, including his latest four: *Digital Wedding Photography Secrets, Rick Sammon's Digital Photography Secrets, Face to Face* and *Exploring the Light*—all published in 2008! His book, *Flying Flowers* won the coveted Golden Light Award, and his book *Hide and See Under the Sea* won the Ben Franklin Award.

Rick has photographed in nearly 100 different countries and gives more than two dozen photography workshops and presentations around the world each year. He also hosts five shows on kelbytraining.com and writes for *PCPhoto, Layers* magazine and photo.net.

Nominated for the Photoshop Hall of Fame in 2008, Rick Sammon is considered one of today's top digital-imaging experts. He is well-known for being able to cut through Photoshop "speak" to make it fun, easy and rewarding to work and play in the digital darkroom.

When asked about his photo specialty, Rick says, "My specialty is not specializing."

You can catch Rick at Photoshop World, which he says is a "blast." See www.ricksammon.com for more information.

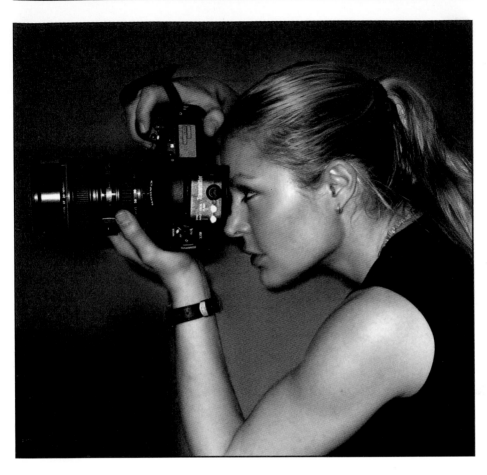

Vered Koshlano

New York City-based professional photographer Vered Koshlano (www.byvk.com) specializes in fashion, beauty, glamour and studio photography.

Combining her experience as an actor in front of the camera with her technical know-how, Vered produces technically exquisite photographs that convey the feeling and mood of the subject … something that she strives for in each and every image.

Recently, Vered teamed with award-winning photographer/ author Rick Sammon (www.ricksammon. com) for a book (Rick's 34th) on studio lighting: *Studio Lighting Secrets*. Throughout this book, you'll see dozens of photographs taken in Vered's studio, illustrating different lighting techniques as well as tips on how to work with models and create different moods in a photograph. Posing, makeup and props—other Vered specialties—are also covered.

Recently, Vered was a featured instructor at the Lepp Institute of Photography and was commissioned by Canon USA for a series of portraits featuring well-known photographers/ artists for its Print Master program. She is also Rick's co-host in his Wiley Publishing how-to DVDs: *Canon Digital Rebel XS, Canon Digital Rebel XTi* and *Basic Lighting and Portraiture.*

Credits

Acquisitions Editor
Courtney Allen

Project Editor
Jenny Brown

Technical Editor
Alan Hess

Copy Editor
Jenny Brown

Editorial Manager
Robyn Siesky

Business Manager
Amy Knies

Senior Marketing Manager
Sandy Smith

**Vice President and
Executive Group Publisher**
Richard Swadley

Vice President and Publisher
Barry Pruett

Book Designer
Erik Powers

Media Development Project Manager
Laura Moss

**Media Development Assistant
Project Manager**
Jenny Swisher

Rick's Acknowledgments

In Vered's acknowledgements that follow, she begins by saying, "It's not easy being an artist." I agree one hundred percent.

To this I add: It's not easy being an author. Once you put something in print, that's it—forever. Kinda scary for someone as sensitive as myself. I am my strongest critic, and I have been known to change my mind a time or two.

It's also not easy working with another person on a creative project … simply because every artist and author has his or her own creative expression and way of doing business. For example, at the time I get up in the morning to work, Vered is just going to bed!

When I began this project with Vered, she was my co-host on several Wiley how-to photography DVDs. The first thing I said her was, "I hope we are still friends when this project is completed."

Well, not only are we still friends, but it turned out that Vered was the perfect partner for this book. She not only supplied wonderful images and information, but she was also extremely accommodating and flexible during the entire process. So my first "thank you" goes to Vered, who is sleeping while I write this at 5:30 am.

There are many others who helped me along the path to producing this book, which is my 34nd.

The guy who initially signed me up with Wiley is Barry Pruett. Barry has a quality that every author needs: faith that someone actually wants to hear what (s)he has to say! Thanks to Barry, I have four DVDs with Wiley and now three books.

For all of these Wiley books, Courtney Allen, a super-talented acquisitions editor, helped me big time—with everything you see between the front and back covers. Not an easy task, to say the least.

More help was on the way at Wiley's end!

Alan Hess, my technical editor, added his expertise and made sure no one receives the wrong information here. Thanks Alan!

I also want to thank Jenny Brown of Brown Ink for her excellent work as Copy Editor and Project Editor; Erik Powers of Creative Powers for his phenomenal job at designing and producing the book; and Mike Trent for his work on the front and back cover design. Thank you all for your eagle eyes and artistic flair … and for patience working with me!

Someone who has been helping me for 59 years also worked on this book. My dad, Robert M. Sammon, Sr., who is almost 91, actually read each and every word, using his wordsmith skills to improve my words! I could not have done it without you, dad.

Two more Sammons get my heartfelt thanks: my wife, Susan, and son, Marco. For years, they both supported my efforts and helped with the photographs. Thanks Susan and Marco for all your help and love.

Westcott, producers of an extensive line of lighting equipment, played an important role in producing this book as well. They supplied studio and on-location gear for several of the shoots. A big thank you goes to Kelly "Wonder Woman" Mondora for all her support over the past year. Westcott's David

Piazza and John Williamson, with whom I've worked at trade/ consumer shows, get my thanks, too. You guys rock!

Bogen's Kriss Brunngraber also helped big time with this book, supplying us with the best tripods and stands for lights in the world. Thanks Kriss, you da man!

Much appreciation goes to Joe Brady, field marketing manger, MAC Group, for supplying the text and PocketWizard photos for the Unleash Yourself chapter and to Alan Hess, the wonderful tech editor on this book who suggested that we mention that PocketWizards also work with Nikon flash units. And thanks to Jenny Brown, my editor, who suggested that you can also use PocketWizards for wildlife photography. Me? I supplied the other photos in this chapter.

In the Student Studio Lighting Experiments chapter, you'll see some wonderful work by several student photographers at the Hallmark Institute of Photography. I'd like to thank these individuals for sharing their work and lighting secrets. I'd also like to thank Hallmark's Vern McClish and Lisa Devlin Robinson for coordinating the student's work for this book.

The photographers who contributed images and tips to the With a Little Help From Friends chapter also get a big thank you. Their works is amazing, and I encourage you to see more of it on their web sites.

Other friends in the digital-imaging industry who have helped in one way or another include Mike Wong and Craig Keudell of onOne Software, Wes Pitts of Outdoor Photographer and PCPhoto magazines, Ed Sanchez and Mike Slater of Nik Software, Scott Kelby of Photoshop User magazine and Chris Main of Layers magazine.

Rick Booth, Steve Inglima, David Sparer, Peter Tvarkunas, Chuck Westfall and Rudy Winston of Canon USA have been ardent supporters of my work and photography seminars … so have my friends at Canon Professional Service (CPS). My hat is off to these folks, big time! The Canon digital SLRs, lenses and accessories that I use have helped me capture the finest possible pictures for this book.

Jeff Cable of Lexar hooked me up with memory cards (4GB and 8GB because I shoot RAW files) and card readers, which helped me bring back great images from my trips. Thanks Jeff.

And not to be forgotten, my photo workshop students were, and always are, a tremendous inspiration for me. Many have shown me new digital-darkroom techniques, some even used in this book. I find an old Zen saying to be true: "The teacher learns from the student."

So thank you one and all. This book could not have been produced without you!

Vered's Acknowledgements

It's not easy being an artist. Although it may be satisfying on a personal level, getting "out side" approval means a lot—and not just from a financial standpoint. If no one applauds at the end of the show, the actor is likely to be devastated … no matter how good he thought his performance was. So when Rick asked me to do this book with him, I was more than just happy.

I have known Rick for a few years now, and we collaborated on a couple of his DVD projects, so I knew working with him was going to be fun. But as Rick says: "Having fun is hard work!" Turns out, this is true. And I would like to take this opportunity to thank him for bringing me on board for this wonderful adventure!

Rick has been working with Wiley publishing for a long time, and when he suggested me as co-author on this book, they simply trusted that he found the right person for the job and welcomed me graciously!

A big thank you goes to Canon for making amazing picture-taking machines that allow me to make beautiful images effortlessly, so I can concentrate on the creative side of the project rather then be a "heavy machinery operator."

Speaking of Canon, I have been very fortunate in meeting a few wonderful people who, throughout time, have offered their support, technical guidance and trust in my abilities: Mr. Hitoshi Doi, David Sparer, David Carlson, Corinne Cortez, Steve Inglima, Chuck Westfall, Rudy Winston and the guys entrusted with the expensive toys, including Joe Dolora, Steve Losi, Frank and Paul from Canon Professional Cervices (CPS). I am proud to be part of the Canon family!

In these times of digital everything, photographers wouldn't do very well without the digital darkroom afforded to us by companies such as Adobe (Photoshop and the whole creative suite), OnOne, Nik, BreezeBrowzer and lots of other software manufacturers that make it easy to mange and publish our digital work—a big warm thank you to you all!

A special thank you goes to Westcott for generously lending us top-of-the-line lighting equipment to experiment with. (I love everything!) Kelly is my wonder woman!

I thank all of our photographer friends who took time out of their busy schedules to share a lighting tip with our readers. Make sure you look them up and keep learning.

Finally I would like to thank the talented people (makeup artists, hair and wardrobe stylists, models and assistants) who collaborated with me to make wonderful images!

After writing 34 books, I've run out of family members, friends, workshop students and research foundations for a dedication.

So this one is for the person who said:
"He who writes lives forever."

Unfortunately, that person is dead.

—Rick Sammon

For my wonderful parents Rina and Zalman Koshlano, who still wait for me to become a doctor, and to the one soul that's a part of me, my beloved Jonathan: "Separation is but an illusion."

—Vered Koshlano

Contents

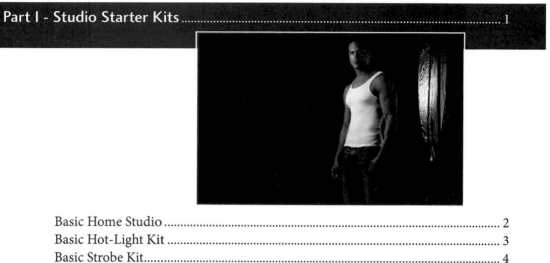

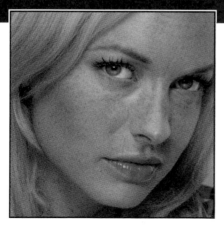

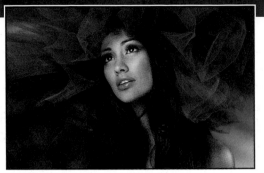
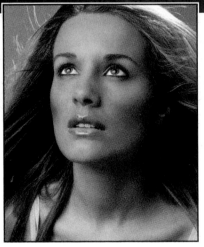

Part V - Hooked on a Feeling

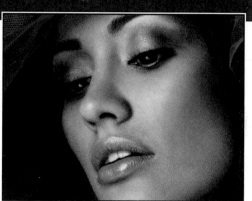

Part VI - Oh, the Details

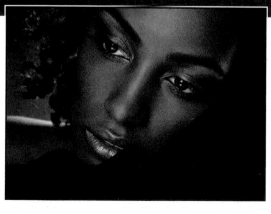

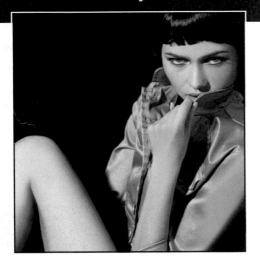

Part IX - Unleash Yourself

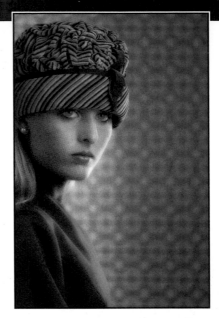

Part XI - Student Studio Lighting Experiments

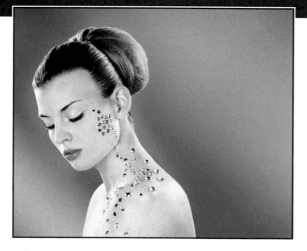

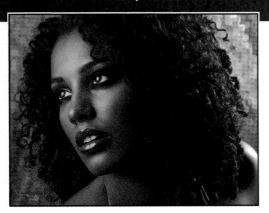

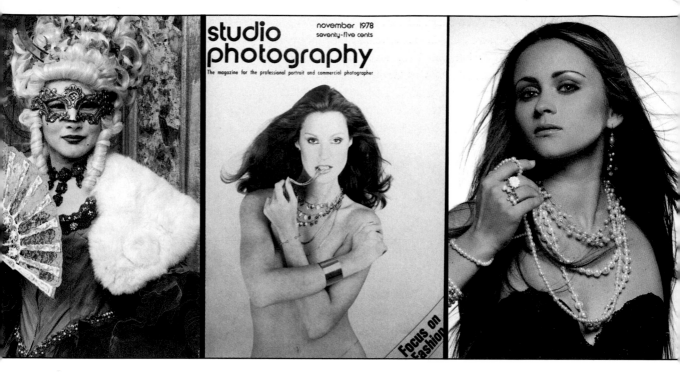

Introduction

Those of you who know my work know that I specialize in travel photography … and often jaunt off to places such as Mongolia, Thailand, Kenya, Namibia, Central and South America, Fiji, Morocco, the Arctic, Antarctica, Galapagos, Vietnam, Cambodia and Italy's Venice (where the photograph on the left was taken) to make photographs for my books, magazine articles and web sites.

So you may be surprised to find me doing a book on studio lighting. Heck, I don't blame you. As recently as May of 2008, while I was photographing Huli Wigmen in Papau New Guinea, this book was not even a concept. But as I began thinking about lighting techniques, it became clear that there are definitely tools and methods that work well … and some that don't. This book contains ideas, techniques and ways to use equipment in various types of photography studios as well as out in wide world of on-location photography.

But here's the thing: Photography is always about, well, *photography*. The principals of lighting, composition, exposure and working with subjects (in the case of photographing people) remain the same. The three images above were taken in different locations by different photographers and span 31 years; they illustrate my philosophy well.

So when Wiley Publishing asked me to do a book on studio lighting, I jumped at the chance. What fun, I thought …. keeping the following expression in mind: If you want to become an expert on something, write a book about it. That is, while I don't consider myself a lighting expert per se, I do know that it's critical to understand the tools and fundamentals of studio and location lighting in order to capture the images you foresee.

To begin the project, I dug out some old issues of *Studio Photography* magazine. I served as editor of this magazine from 1978 to 1980—before being hired by a NYC advertising/ public relations agency to head up a major camera account—so I had a bunch of back issues! The cover you see here is one of my favorites. It captures my constant appreciation for the magic that one can create in the studio. For this and other issues of the magazine, I ran articles on the Best of the Best when it came to studio photography, and I learned much about the craft of studio shooting along the way—absorbing tips, tricks and techniques that I would later apply to my people-based travel photography.

The next step was to get a co-author. That decision took about half a minute. Vered Koshlano, who took the studio portrait on the right (previous page), was the logical choice. Her expertise in all aspects of studio lighting and working with models is incredible. She's among the best. This, you'll discover for yourself throughout this book.

On the following pages you'll find photographs and tips from not only Vered and myself, but also from some of the top studio pros in the country. It was totally awesome to get them, as well as some talented individuals from the Hallmark Institute of Photography, involved in this project. I have been giving four seminars at the Institute over the past four years, and I just love the work these dudes produce. Talk about learning a lot!

I think you'll like the layout of this book, too. There's one tip per page (in most cases), so you really don't have to read this in any particular order. Find picture you like, check out the technique and try it (or a variation of it) in your home, professional studio or on location.

And let us know how it goes! Vered and I would love to hear from you. You can contact me through twitter.com/ricksammon—a short and sweet method of communication. You can also reach us through our web sites: www.ricksammon.com and www.byvk.com.

Before I go, I'd like to leave you with one of my favorite expressions. It is one that makes great sense when it comes to photography:

> *I hear, I forget*
> *I see, I remember*
> *I do, I understand*

Have fun doing it! Enjoy the process.

Rick Sammon
Croton-on-Hudson, NY
August 2009

Part I

Studio Starter Kits

You don't have to use thousands of dollars of studio gear to get professional quality results—although, no doubt, it can make your photographs look more professional. In this chapter, find out how to shoot on a budget … and still get professional results.

Basic Home Studio

Here's a look at a very basic home studio. It can be set up in about 15 minutes for around $700.

In the picture of my den (on the right), the light on the right side of the subject is a hot light (constant light source) mounted in a softbox (to diffuse the light). To the left of the subject is a reflector, which bounces light from the hot light onto the opposite side of the face. In the background is a black cloth, the kind you can pick up at a fabric store.

I took the photograph on the left with this simple and affordable setup.

Photo courtesy of FJWestcott © John D. Williamson

Basic Hot-Light Kit

Hot lights are called *hot lights* because, well, they get hot. They provide a constant light source so that you can see in real time the effect (shadows and highlights) of using one or more lights and changing their positions.

Hot light kits can cost thousands of dollars, but there's a three-light PhotoBasic kit from FJ Westcott that sells for about $500. The 11-piece PB500 kit includes: two main lights, two umbrellas to soften the light, a background light, three stands, a background, a floor mat for easy light placement and a carrying case.

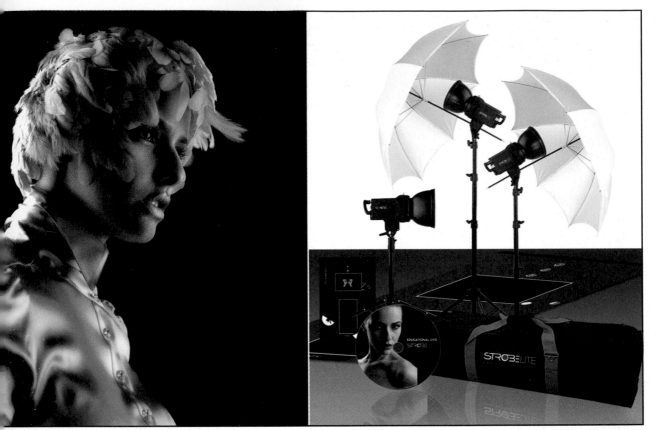

© Eric Eggly Photo courtesy of FJWestcott

Basic Strobe Kit

Strobe lights work like an accessory camera flash, firing in the blink of an eye. They have photocells that allow them to be fired from a main strobe that is tethered (attached by a wire) to a camera.

Professional strobe light kits can be pricy though, costing several thousand dollars. Rather than spending these big bucks, you might want to start with a three-light PhotoBasic kit from FJWestcott. The 12-piece Strobelite Plus 3 Light Kit #231 costs around $700 and includes: three lights, two softboxes (to soften the light), two adaptor rings (to swivel the softboxes), three stands, a carrying case and a Westcott instructional DVD.

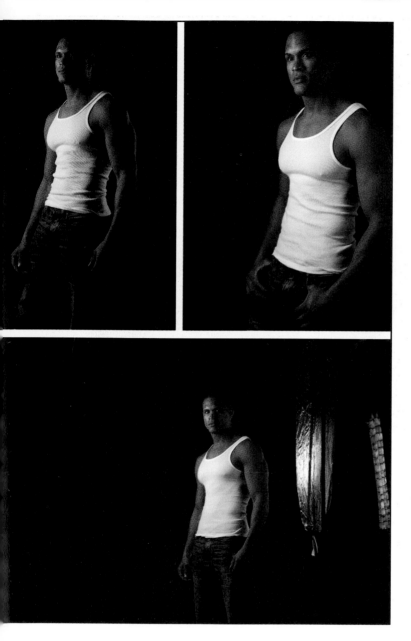

Simply Beautiful

Here is an example of how you can create a beautiful portrait with a very simple lighting setup.

For the top left photograph, a strip light (no grid) was positioned in front of the model and to camera left. This provided the main light source. A strip light was positioned behind the subject and to camera right to provide the accent light on the model's left arm. Half of the model's face is in a shadow, which makes for a dramatic image.

For the top right photograph, a reflector was used in combination with the main light. We can see the model's face better in this image, but it does not have the drama of the image with the strong shadow. Still, we like it.

The bottom photograph shows the simple behind-the-scenes setup.

Try to keep it simple, or try to at least *start* with a simple setup like this. Good fun … and good lighting.

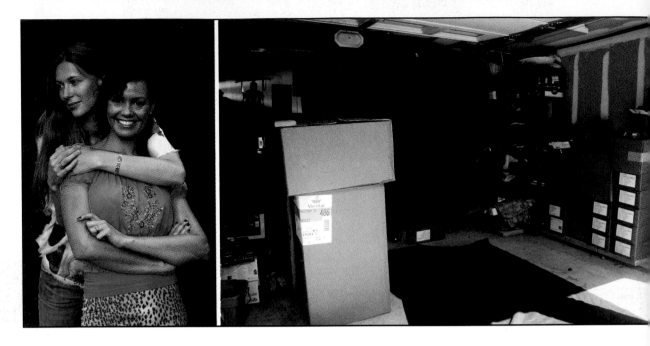

Garage Glamour

If you have a garage, or access to one, you can create a natural-light studio in just a few minutes. And your garage studio can produce soft and even lighting—with daylight from the large open door. All you need to add is a background (the more professional looking the better) and a large black cloth.

I took the photograph on the left in my garage. Check out the soft and even lighting on the models' faces. On the right is a picture of the garage packed with boxes of my books and boxes of construction materials.

A background is needed to create the impression that the portrait was taken in a professional studio. And the black cloth eliminates the effect of light bouncing off the cement floor, which is usually stronger than the light bouncing off the walls and ceiling of the garage.

You can control the brightness of the background by moving it closer to (brighter) or away from (darker) the subject.

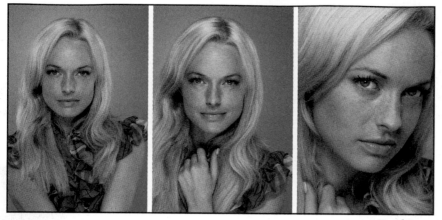

© David Sparer

Part II

Our Lenses

You know the old expression: *Cameras don't take pictures; people do*. Well, here's another one: *Cameras don't take pictures; lenses do*.

In this chapter, our friend David Sparer—Senior Manager/ Technical Marketing, Professional Products Marketing Division, Canon USA—illustrates how using different lenses affects a portrait.

Above are a few of the photographs you'll see in this chapter. They show a bit of Photoshop retouching by David. Otherwise, the studio photographs in this chapter are straight out-of-the-camera shots and were taken in the photo studio at Canon USA's headquarters in Lake Success, New York.

David used a Canon EOS 5D Mark II. All the Canon lenses used for the photographs in this chapter were set at f/13. The ISO was set at 100.

This chapter also includes a few behind-the-scenes shots, so enjoy!

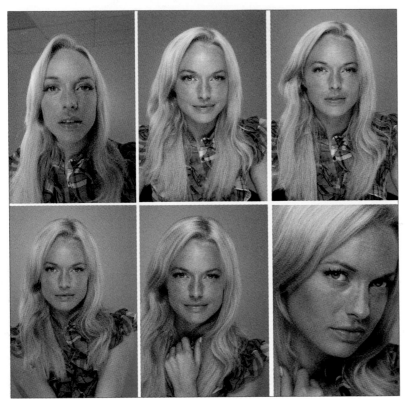

© David Sparer

Love Those Longer Lenses

One of the pictures on this page looks awful; the model's features are all distorted. Some look okay, and some are outstanding. Basically, it all comes down to the lens that was used. The lighting and model remained the same; only the lens and the camera-to-subject distance changed.

Top row lenses (left to right): 24mm f/1.4 L II, 50mm f/1.2 Land, 85mm f/1.2 L II.

Bottom row lenses (left image): 135mm f/2.0 L. Middle and right images: 200mm f/2.0 L IS lens … with an extension tube to shorten the minimum focusing distance.

At a close shooting distance, the 24mm lens distorts a model's features, making this lens a no-no for portraiture. But it's quite suitable when taking an environmental portrait—that is, a portrait of a subject in his or her environment. What's more, with a 24mm lens, you need to be virtually "on top of" the subject for a shot. That can get uncomfortable.

The 50mm and 85mm lenses are okay, but they also require you to work relatively close (often too close) to the subject. The 135mm lens is a good choice, but the 200mm lens is the best option for headshots and head-and-shoulder shots. It allows a comfortable photographer-to-subject distance; but more important, it produces a flattering effect.

Choose your lens wisely. Love those longer lenses. They love the subject.

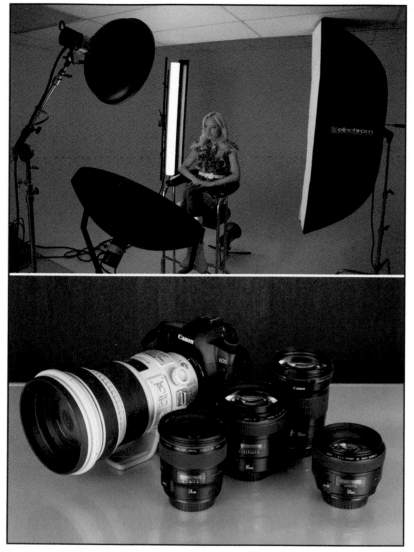

© David Sparer

Studio Lighting and Lens Lineup

Here is a look at the lighting setup that was used for our lens shoot. Softboxes, beauty dishes and a background light (all skillfully balanced using a light meter) were used to produce the beautiful lighting you see in David's photographs on the previous page. Modeling lights in the strobes helped with the light placement and revealed shadows and highlights before the pictures were actually taken. When choosing studio strobes, consider the benefits of shooting with strobes that have built-in modeling lights.

David's lenses for the shoot are described on the previous page. Next, take a look at pictures we took with his trusty Canon EOS 5D Mark II (next page).

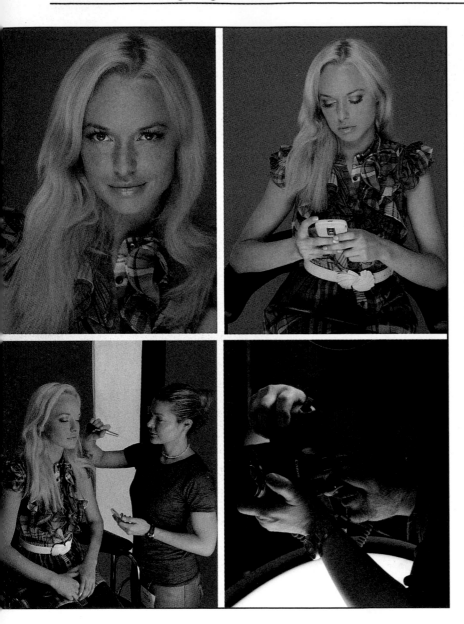

Modeling Light and Fun Photos

On the previous page we talked about one of the benefits of using strobes with built-in modeling lights: They help with the strategic placement of strobes.

Well, there is another benefit to shooting with this kind of strobe: You can actually take pictures using just those lights. Just keep in mind that modeling lights are much lower in power than strobes, so your aperture needs to be wider and your shutter speed needs to be slower—at the same ISO you'd set for strobe shooting—to achieve a well-lit photograph. This means, for modeling-light shots you'll need to boost your ISO.

I took the top two photographs using only the modeling lights. The top right photo is the most commonly seen model pose in the studio; it's the model checking email.

I also shot the bottom two photographs. One shows Vered applying powder to our model's face (to eliminate reflections from the lights), and the other shows the intrepid David Sparer at work behind the lens.

As you can see, David is shooting with both eyes open, which is the pro's way to shoot. With both eyes open, a photographer can see what's going on around the main subject, which is especially important when helpful assistants and friends are walking around on the set—and could unintentionally walk into the frame.

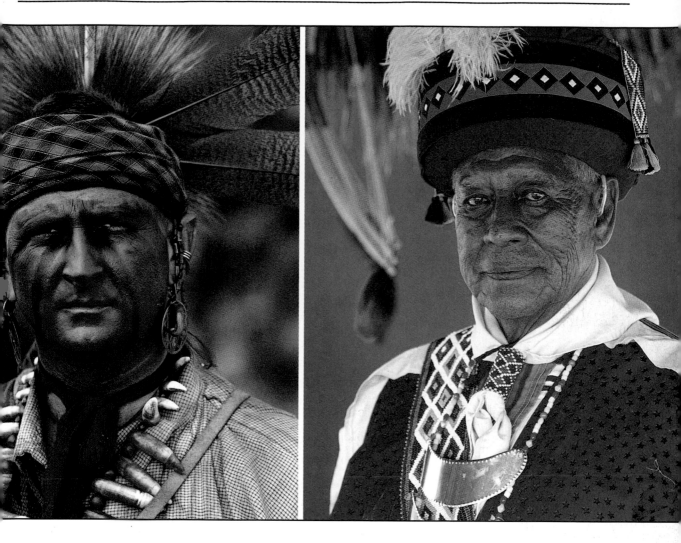

Favorite Lens for On-Location Portraits

If I could take only one lens for portraits with me when I travel, it would be my 24-105mm image-stabilizer lens.

At the 85-105mm settings, I get to shoot nice portraits from a comfortable shooting distance. At relatively wide f-stops (f/4.5 and 5.6), I can get a sharp shot of my subject while blurring the background. This makes the subject stand out in the frame.

I photographed these two Native American reinactors in Florida.

Favorite Lens for Environmental Portraits

If I could take only one lens for environmental portraits with me when I travel, it would be my 24-105mm image stabilizer lens. That's right! It's the same lens I use for on-location portraits.

At the 24-50mm settings, using relatively small f-stops (f/8 and f/11) I can get an entire scene in focus. I took the top photograph in Lombok, Indonesia; I shot the bottom photograph in Montana.

Part III

Photo Composition and Model Positioning

Few pros go into the studio, set up their lights, frame their subjects, shoot, and then say, "That's it!" Most shoots are a deeply considered, evolutionary event—a creative process in which lights are arranged and rearranged, models are posed and repositioned, exposures are varied, and so on.

In this chapter, see some of our studio shoots and the madness behind some of the methods.

Shoot Horizontals and Verticals

As much as you may prefer a horizontal shot over a vertical, or vice versa, shoot a subject both ways. By doing so, you offer a client—or a book or magazine publisher—an important choice.

In the case of publishing, your photograph may fit into available space on a page one way. Limiting your format options may limit the use of your images. What's more, you may change your mind after the shoot on which generates the better composition.

And who knows? An art director may want to use your photograph for a horizontal or vertical poster. How cool! Here, too, you don't want to miss out on a sale because your image does not fit the client's specifications.

By the way, if you only have a horizontal and the client wants a vertical, don't panic. With the resolution of today's cameras, it's easy to crop a horizontal image vertically; but you may not have exactly the same ratio that a vertical image offers.

As long as we are talking about clients, check out the open space in these two photographs; this is the space around the faces. Art directors like open space in a photograph because they often need to place type on a photograph. And as much as you may not like anyone messing with your photographs, you gotta go with the flow if you want to make it in the highly competitive world of professional studio photography.

Get Close and Closer

Usually, an art director or client wants a specific shot: headshot, three-quarters shot, etc. Sure, you must deliver. But as long as you're at it, take shots for yourself and for the model's portfolio and for web sites.

To keep the pace fast (and fun), use one lens, such as a Canon 24-105mm zoom. Also, use the techniques that pros used before zoom lenses were invented: zoom with your feet.

Once your lights are set up, shoot in the Av (aperture priority) or in the Manual mode with a constant aperture.

Also experiment with the model's pose and body position. On the left, the image is head on; the pose is angled in the other two photographs.

When you are moving around your subject and zooming in, and/ or when you're working with a model that's moving, keep an eye on the lighting. This was the situation for these three photographs. In the image on the left, the backlight, pointing at the model, is visible in the photograph. It could have been hidden easily, but seeing it adds a nice touch to this fashion shot.

In the photograph on the right, the light behind the model created some lens flare (in the bottom right of the photograph). Here, too, we like the effect.

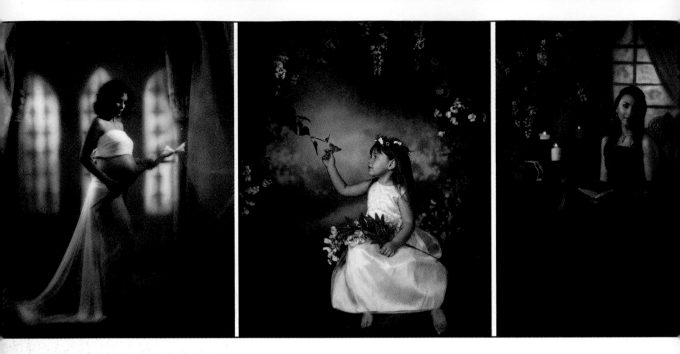

Bank on Professional Backgrounds

These photographs were taken in a New York City studio with bare cement walls. The beautiful backgrounds are painted fabrics that roll up for easy storage. Search online for photographic backgrounds. Check out L&B Backgrounds and Frames (www.lbalbumframe.com).

Look closely and you'll see that some props, which create a sense of depth and enhance the settings, have been added to the scenes. Notice the white sheers and a flower pot in the left photograph; the hanging flowers in the middle photograph; and the table, chair, books, candles and vase with flowers in the image on the right.

When working with backgrounds, it's important to pay extra attention to lighting them. Remember, you can control the brightness of the background by adjusting your lights, and you can adjust its color by adding different color gels over the lights.

Of course, you can also change the brightness, color and sharpness in Photoshop, which we'll cover in the Photoshop Enhancement chapter.

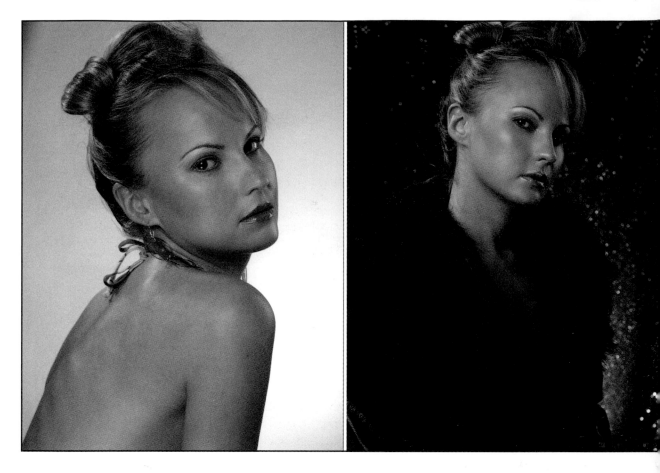

The All-Important Background

This model is lit similarly in both photographs. The big difference, other than her wardrobe, is the background.

As mentioned on the previous page, you can use gels to change the color of the background. Changing the color also changes the mood of the photograph.

Keep as many different backgrounds and gels on hand as you can afford, because you'll need dark and light, soft and strong, and textured and solid backgrounds to create different effects for your shoots.

When working with backgrounds, it's often a good idea to use what's called a *separation light*—one that's pointed at the background to provide some separation between your subject and the background. Although, as you'll see in the next chapter (Dramatic Hair Light), this isn't always the way to go.

The point here is to recognize the effect of a background light and note how different backgrounds affect the mood of an image.

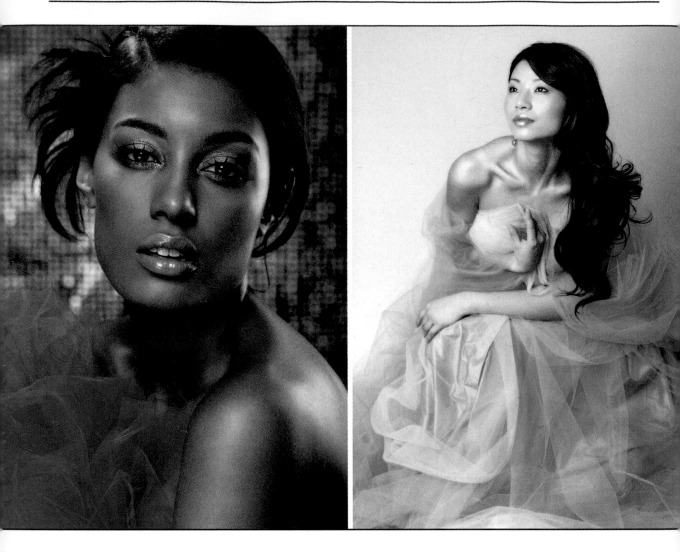

Contrasting Colors vs. Tone on Tone

These photographs illustrate two important studio set-up techniques. The image on the left features contrasting colors between the subject and the background to create a bold effect. The photograph on the right illustrates the tone-on-tone effect, where similar colors are used to create a soft and pleasing effect—pastel in this case.

As a pro, you need to be prepared to create these different types of photographs. Having a variety of backgrounds and different gels (to change the color of your backgrounds) helps big time!

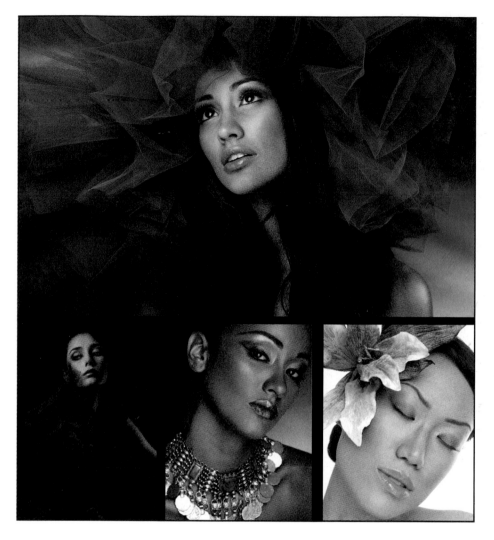

Props Pay Off

When it comes to fashion and beauty photography, props pay off. Props help these photographs look professional.

Yet there's no need to spend a fortune on high-ticket props to get professional-looking results. A visit to a fabric store can yield some cool background and trimmings. At a local flower shop you may be able to pick up some silk flowers that can be used over and over again. Want some fancy jewelry? Do a web search on costume jewelry. Need cool clothes? Check out a Salvation Army or Goodwill store.

And of course, flea markets are great places to find lots of cool stuff.

If you work with affordable props regularly, then when a high-end product client calls, you'll have examples of your prop work. Just don't tell 'em were you got them.

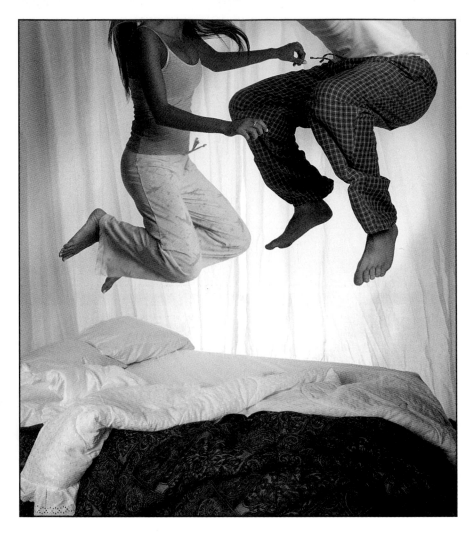

Shooting a Composite

The photograph above is a composite of the three other images you see on the right page. Here is how Vered created the image.

The first step was looking at the art director's sketch of the desired picture.

The next step was to create a lighting setup that would work for all three photographs—that is, a setup that remained constant in terms of exposure, shadows and highlights. This ensures that the pictures in the composite appear to have been taken at the same time.

Scale, too, had to remain constant. This is the purpose of all the white space surrounding the subjects in the bottom photographs.

The final step: Vered skillfully combined the images in Photoshop.

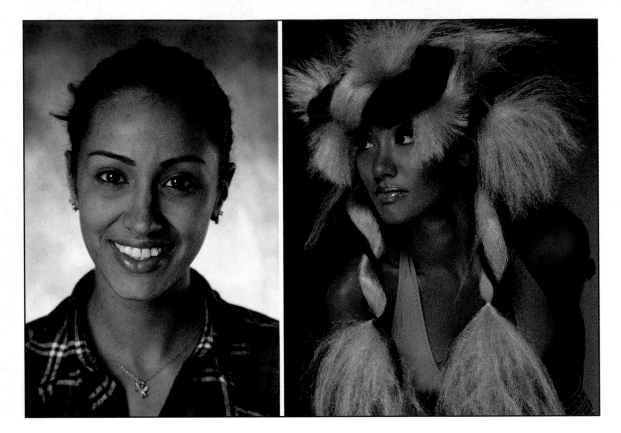

Finding and Working with Models

When Vered first saw Stephanie Garcia in a mall on Long Island, New York, she looked pretty much the way she looks in the pre-shoot snapshot on the left.

With a studio photographer's eye, Vered saw the model potential in Stephanie. This potential is apparent in Vered's studio shot on the right.

The point is that you don't need to hire $10,000-a-day models to get great studio shots. Remember, all professional models were amateurs at one time. Keep your eye out for potential subjects wherever you go. If you see someone with a look you want to capture in photographs, it doesn't hurt to ask if (s)he is interested in doing a shoot. If you have an iPhone, showing a potential model that you have taken some classy shots is a good idea.

When it comes to working with models and clients, make it fun. It's important to keep your subjects interested in the shoot, so talk with them during the photo session. Playing music helps, too. You can also make the session more interactive by showing the model his or her picture on your camera's LCD monitor … or your laptop, if you are doing tethered shooting—that is, working with your camera attached to a monitor.

It's also a good idea to have model releases on hand. It makes you look more professional.

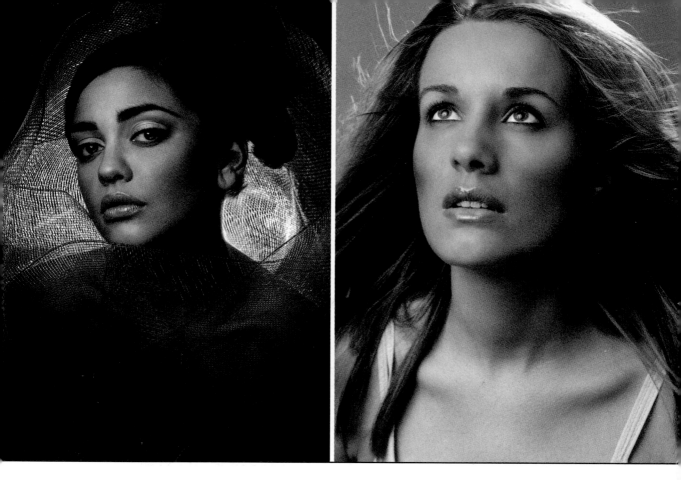

Part IV

Creative Lighting Tips

Vered and I started writing this book by selecting some of the photographs in this chapter from her portfolio and then writing a creative concept for each. You'll find lots of good ideas here to help you awaken the artist within.

In this section, find new ways to work with lights and accessories to create timeless images that you and your clients will love. Good reading and good fun.

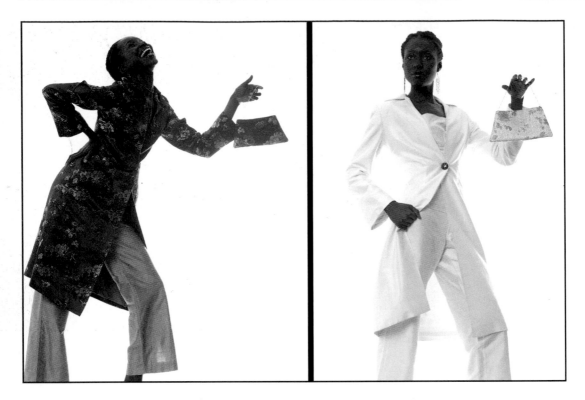

Overcome Meter-Challenging Exposure Situations

As a studio photographer, you need to be prepared for all types of lighting and subject situations. And some are more difficult than others.

The photograph on the left was an exposure challenge because the dark-skinned model was posed in front of a bright-white background. The photograph on the right was even more challenging, because the model was wearing a white outfit. Ahhhh!!! White on white; it's one of the most challenging exposure situations. You need to keep details in the white outfit and prevent it from blending into the white background—all while making sure the background remains pure white!

To overcome this type of situation, it's especially important to get a good in-camera exposure (as opposed to relying on Photoshop for a photo fix). The key is to use a hand-held meter to measure the light on the subject and then to set your exposure to that reading. You'll also want to overexpose the background using off-camera lights (hot lights, strobes or camera flashes), so the background does not end up looking gray in your photograph.

Another option is to position the model away from the background to avoid allowing the background light to spill onto the subject.

Finally, shoot RAW files, which are more forgiving than JPEGs. This forgiveness allows you to rescue overexposed highlights and underexposed shadows, as long as your exposures are not more than an f/stop or two off.

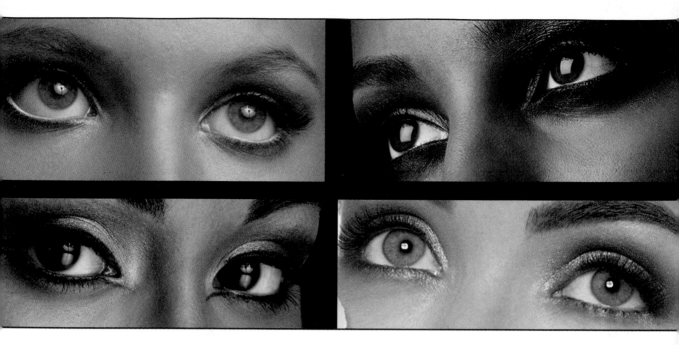

See Light in the Eyes

The Tools of the Trade chapter describes several different lighting setups, and each produces a different end-result. Case in point: Different lighting setups produce different types of reflections in a subject's eyes.

Be aware of those reflections, because a reflection in the eyes (also called a "catch light") can add or detract from a photograph.

Here, the reflections add a nice touch. But reflections can look weird. For example, if you are using three lights, and those three lights show up as three different spots in the subject's eyes, the result will be distracting.

Reduce the size of reflections in a subject's eyes by moving your lights further away from the subject. And you can control where reflections show up by changing the position of the light(s) or the angle of a subject's face.

Here are four examples of different types of reflections (clockwise from top left): 60-inch reflector, square softbox, one umbrella and reflector, and beauty dish.

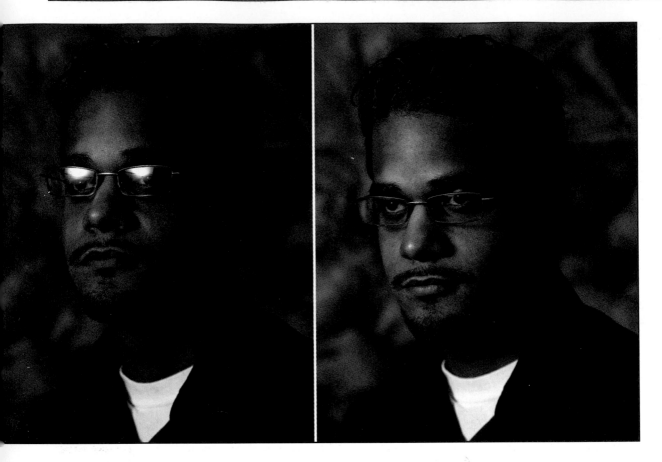

A Word on Eyeglasses

Here is another example of how a reflection can ruin a studio shot. In the picture on the left, the light source (a diffused camera strobe) caused a nasty reflection in the subject's glasses.

To eliminate the reflection while maintaining the same quality and intensity of light, we simply asked Hector (our assistant for the day) to tilt his head downward. You can also change the position of your lights until the reflections disappear.

Depending on where your lights are placed, it may be necessary to ask your subject to position his or her head differently in order to eliminate reflection.

When photographing someone wearing glasses, use the magnification feature on your camera. Zoom in to check for reflections—even small ones, which can be a big pain to remove in Photoshop.

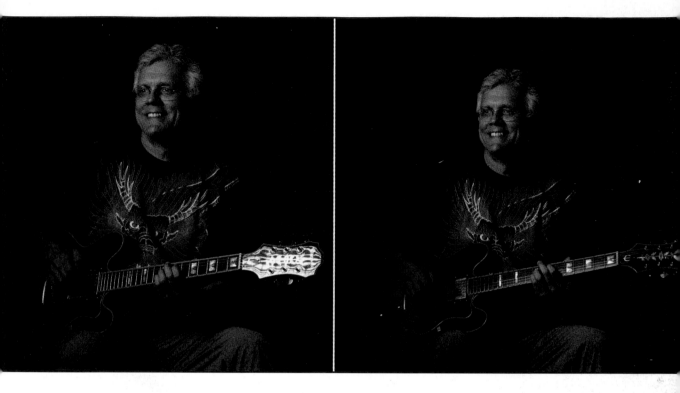

Photographing Shiny Objects

I am playing my Epiphone hollow-body electric guitar in these pictures. One of the things I like about the look of the guitar is its beautiful mother-of-pearl inlay on the neck and head, where the tuning pegs are located.

In the picture on the left, the glossy finish on the head is reflecting light from the studio strobe. The reflection is so strong that the guitar's mother-of-pearl and brand name are washed out. How upsetting for the marketing managers at Epiphone if this picture somehow made it to the cover of *Rolling Stone*!

To eliminate the reflection, use the same titling techniques that we described on the previous page. And, as we mentioned, check for even the slightest reflections on shiny objects or parts of objects by using the magnification feature on your camera.

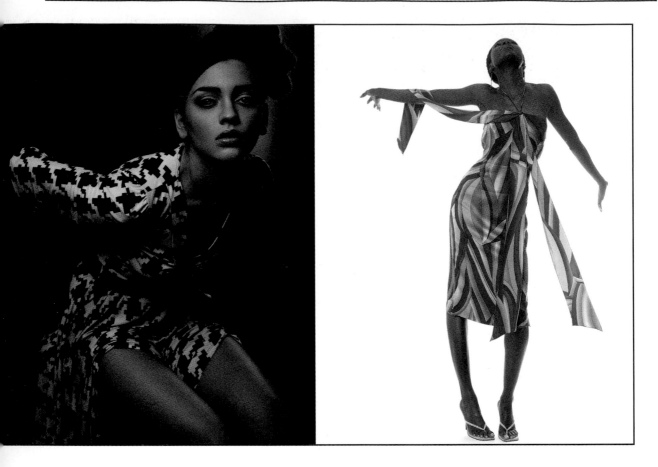

Low Key versus High Key Lighting

These two photographs illustrate two basic types of studio lighting: low key (left) and high key (right).

High key shots are usually created against a white background. To keep the background white, overexpose it by one or two stops (by adjusting your background light or lights).

Low key shots usually have a dark background…and less light illuminating the subject. They're more "moody" than high key shots.

For instance, notice that the low key photograph here has more dramatic shadows than the high key shot.

Master both low key and high key shots, and you'll be on your way to successful studio shooting.

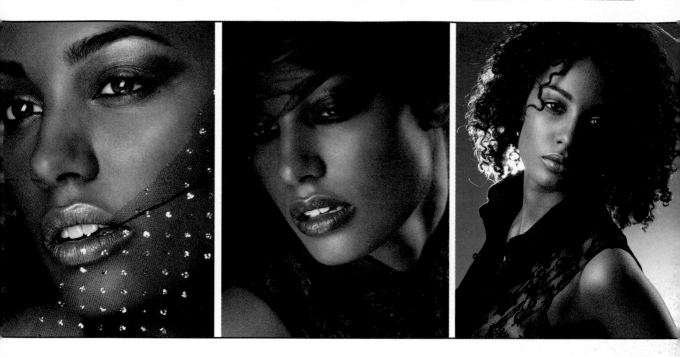

Play with Light Placement

As in all the photographs in this book, the main focus here is the same: *light*. No light, no photograph. In studio photography, light placement is critical.

Here you see the effects of placing light in the following positions:

> Left: in front of the subject

> Middle: in front of and under the subject

> Right: to the side of the subject (with a second light added behind the subject)

A note of caution: If you place the light too close to your subject and below the face, you'll get what's called *Halloween lighting*—you know, the kind of light you used to achieve by holding a flashlight under your chin on Halloween.

By the way, Halloween lighting is used in horror movies to convey that exact feeling.

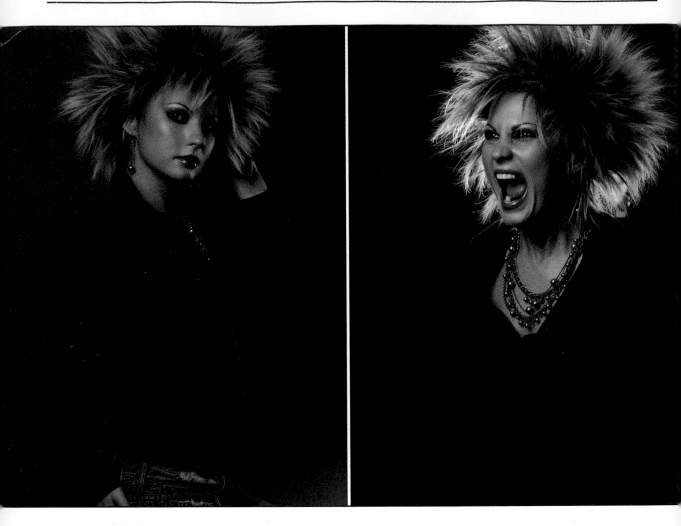

Dramatic Hair Light

For the photograph on the right, a light was placed behind the subject and positioned off camera to the right. It's pointed at the subject's hair to give it a beautiful and intense glow.

A product called Cine Foil (available at B&H Photo/Video: www.bhphotovideo.com) was wrapped around the backlight to narrowly mold the beam, so that light did not spill out onto the subject … or hit the camera lens (which could cause lens flare).

When backlighting a person, be careful not to overexpose the hair. Doing so means you'll lose detail and potentially end up with a distracting effect. That is, you don't want the hair light to be the primary element … unless you are doing a hair shot. To avoid overexposing the hair in this situation, reduce the power output of your backlight.

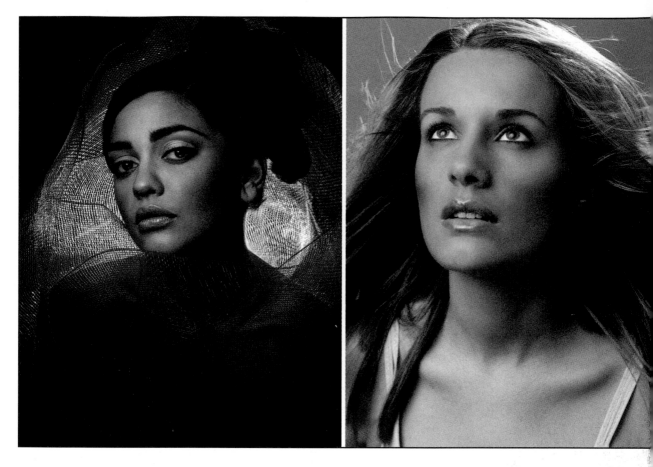

Work Hard at Creative Lighting

All the photographs in this chapter feature creative lighting—some more creative than others.

For instance, the picture on the left required much more work than most of the others. And when you compare it to the photograph on the right (with relatively simple lighting), it's clear that the hard work paid off.

Here's a look at what went into the shot shown on the left.

A spotlight was placed behind the subject to illuminate the metal mesh veil. It was positioned carefully to avoid overexposure. As well, a spotlight with a narrow beam was placed in front of the subject to illuminate her face. No hair light was used.

Notice how light falls off at all four corners of the photograph. If you look at portraits of the Renaissance painters, you'll see that they used this same technique. It draws viewer attention to main subject.

See, hard work pays off ... usually!

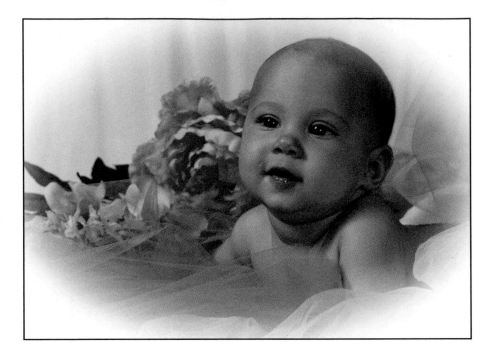

Tips for Baby Shots

From a technical standpoint, baby shots like this require relatively flat and even lighting. This ensures that no matter where the baby looks, the light will be nice and even on his/ her face.

You'll also want to shoot at eye level with the child, as this will put viewers at the same level and allow them to connect more easily with the subject. Avoid taking a "looking down" approach that is so common in snapshots of babies and toddlers.

Adding props (like the flowers in this shot) can further enhance your photo. Just make sure they don't take over the scene or distract from the child in the picture.

A nice digital effect for photographs of young children is a vignette, which softens and lightens the edges of the frame. See the Photoshop Enhancements chapter for more on how to create vignettes.

When working with babies, you'll also want to work fast. And be prepared to take plenty of shots. Don't forget to take photos of those beautiful little hands and feet. Think about creating an awesome collage or classic coffee table book that will make everyone happy!

As far as light type is concerned, have both hot lights and strobes available. Some infants don't like the bright light from hot lights, while others don't like the flash from strobe lights. In any case, you can improve your chances of having a successful shoot by using softboxes, umbrellas or diffusers to soften the light.

Finally, when it comes to needing an assistant, have the mom or dad help out. It's much better than having a second stranger (you being the first) in the room making the baby feel nervous. And while you've got them working on the set, include mom or dad in the portrait. No doubt you'll sell a few more prints!

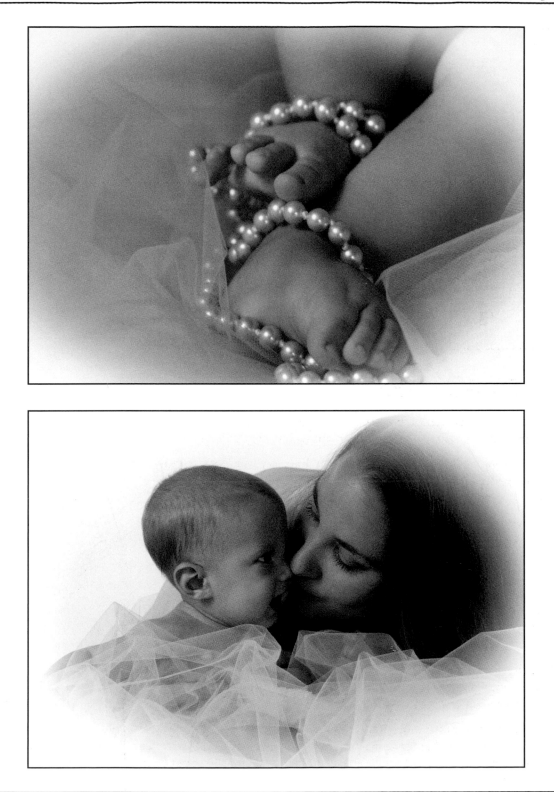

Balancing Act

Here are a few photographs that Vered took of me in her NYC studio. We took these shots, adjusting the light as we moved along, to illustrate different lighting techniques. Clockwise (from top left):

- One strobe light (softbox with egg-crate panel) placed at a 45-degree angle to the subject

- Background light added (but too bright)

- Reflector added and background light output reduced by one f-stop (with a neutral density gel that does not affect colors)

- Reflector moved back two feet from the subject, and background light output reduced by two f-stops

On the opposite page is my personal favorite shot from the shoot: one light with me looking at the light … as opposed to me looking at the camera.

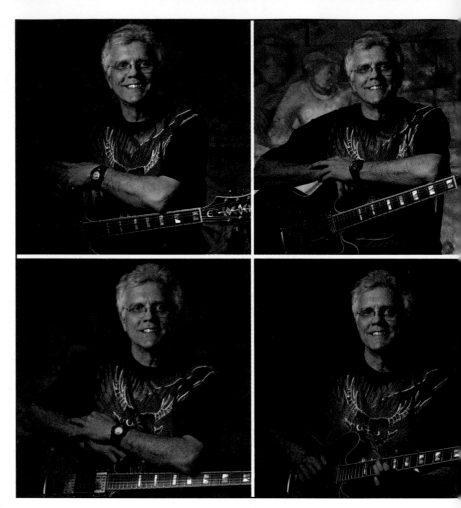

The behind-the-scenes image shows the placement of the lights and reflector. I'm holding a flash meter, which measures the light from the flash and gives an accurate exposure readout.

P.S. There is another reason I like the top shot on the opposite page. It captures the action of me actually playing the guitar and doesn't look overly posed.

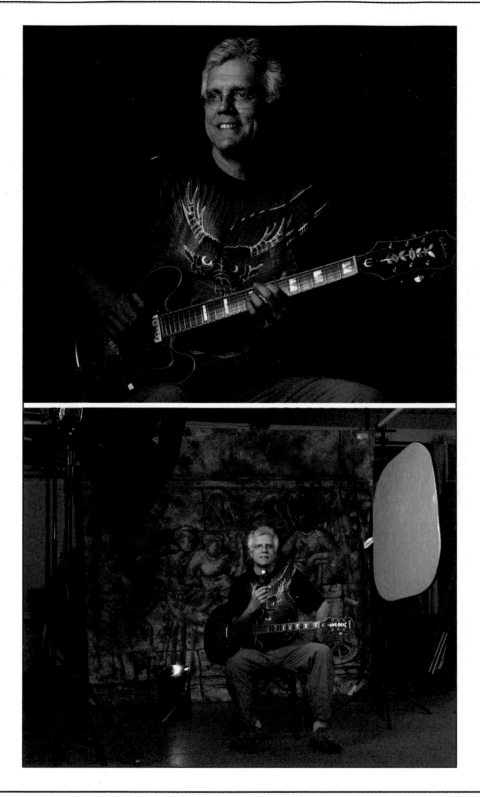

Testing, Testing, Testing

Studio photography is often about testing, testing and more testing … to achieve a desired result. Variations and change—and plenty of outtakes—are commonplace in even the best photo studios.

The left photograph (cropped) on this page is a favorite from the photo session, which also includes the four pictures on the opposite page.

For all the shots, except the bottom right image on the opposite page, two Canon flashes were placed behind diffusers and set at about a 45-degree angle from the subject and fired with a wireless transmitter. These were used to illuminate the model. See the behind-the-scenes-shot for the exact setup.

For the bottom right shot (on the next page), we used a single flash, held off camera, to light our model. More on that in the tip: Repositioning the Flash.

But wait! The background in our "keeper" is white, and it is gray in all the other shots in this spread. How did that happen? Easy. You can turn gray to white as well. To do this, open the Levels panel in Photoshop, select the White Point eyedropper and click on any point in a picture that you want to be white.

Does the model in our favorite shot seem to glow? That effect was created using the Glamour Glow filter in Color Efex Pro from Nik Software (www.niksoftware.com).

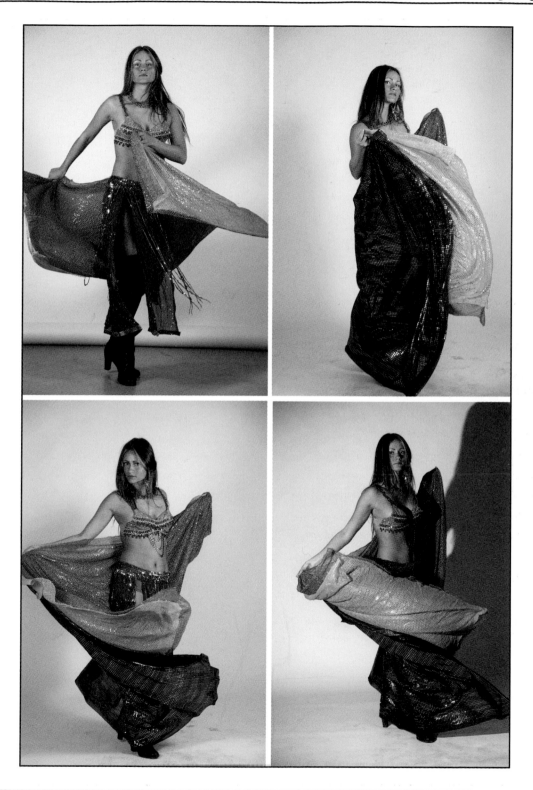

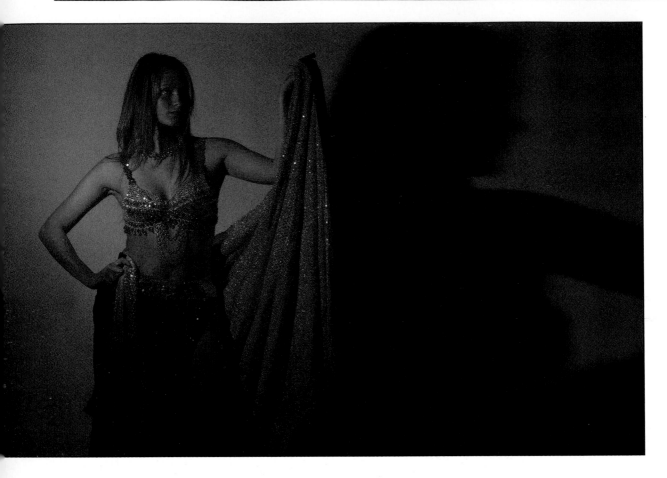

Repositioning the Flash

Honestly, we were not planning on capturing the above shot when we went into the studio. It happened kinda by accident.

We were experimenting with off-camera, wireless flash techniques…something that is illustrated in this Tools of the Trade chapter as well as the Unleash Yourself chapter. It's just so cool!

At first, we held one flash to the left of the model, which created the non-descript shadow you see in the bottom right photograph on the previous page. It's an outtake. However, it revealed the potential of using a good shadow—one that showed the profile of our model.

After directing the model to pose in a few different positions and moving the flash position and adding an orange gel over the flash head, we came up with the photograph above.

On the opposite page are a non-gel shot and a behind-the-scenes shot of this setup. See the orange gel on the flash head?

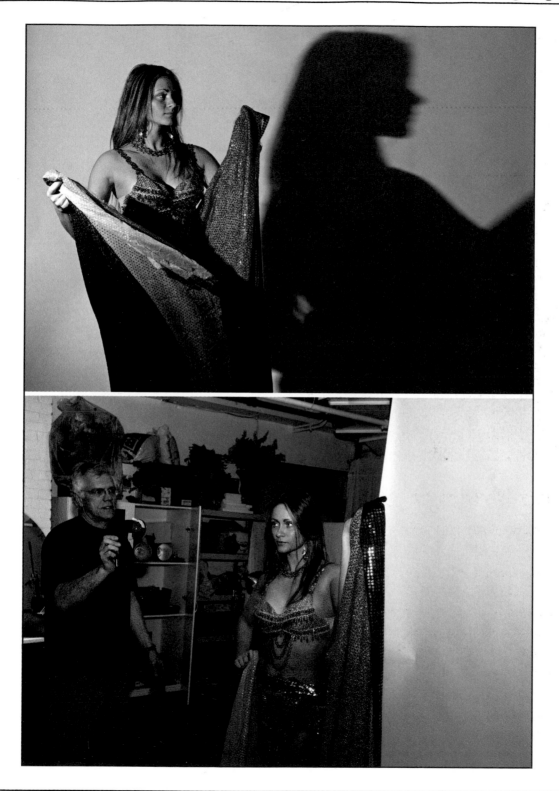

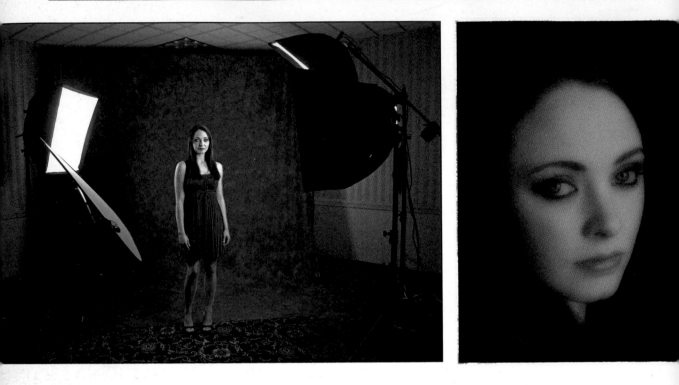

Add an Effect for a Creative Portrait

Here's another basic lighting setup: Main light, fill light, hair light, reflector and a draped background.

The lighting setup produced a nice enough color image. However, when I saw the model's wide eyes, I knew I wanted them to be the main focal point of the photograph. I felt that her makeup and red lipstick detracted from those eyes. So I used the Polaroid Transfer Effect in Color Efex Pro by Nik Software (www.nicksoftware.com) to transform the color shot into a monochromatic image, and it created a more artistic photograph. You see, when you remove the color from a scene, you remove some of the reality. When you remove some of the reality, your picture becomes more artistic.

Part V

Hooked on a Feeling

When I was in college in 1968, *Hooked on a Feeling* by
BJ Thomas was a #1 song. Back then, I liked the idea of
being hooked on a feeling—still do. In photography, as in
many aspects of life, feelings are important. In this chapter,
we take a look at how feelings play into a picture.

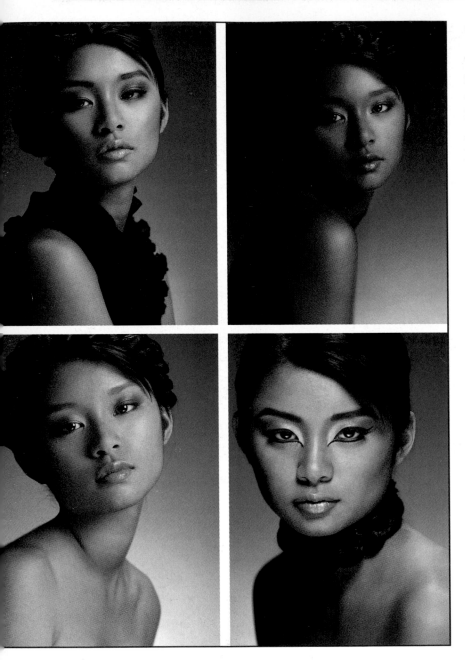

Create a "Look"

The same model is pictured in these photographs. The difference is her "look"—that is, the impression she gives off.

Clockwise (from top left), her looks are as follows:

- I have an attitude; I'm cool.

- I am innocent; it's just me.

- I am tough. Don't mess with me.

- I'm young. What you see is what you get.

This series is a result of the photographer giving direction and the model responding.

When photographing a person, keep this expression in mind: *The camera looks both ways; in picturing the subject, we also picture a part of ourselves.* In other words, be aware that the mood, energy, feeling and emotion that you project will be reflected in the face of your subject.

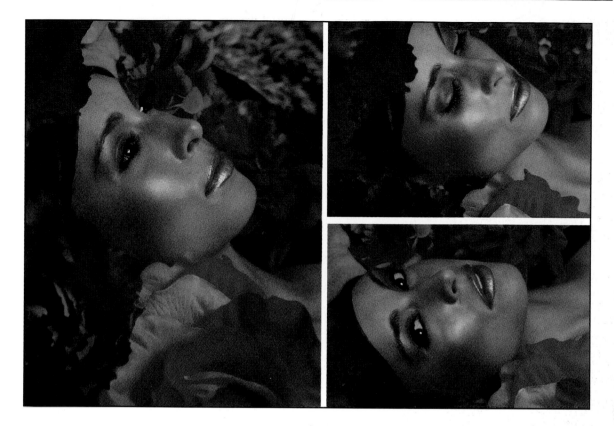

Make Eye Contact … or Not

Check out the eyes in these three photographs. In each photograph, the eyes "say" something different.

In the vertical shot, the model is looking off camera, resulting in a distant feeling between the subject and the viewer.

In the top horizontal shot, the model's closed eyes evoke a sense of intimacy.

In the bottom horizontal shot, the model is looking directly at the camera, engaging the viewer—you!

Most models need directing. Don't be shy about offering suggestions, including what to do with the eyes.

Speaking of eyes, subjects with wide-open pupils (as in the bottom horizontal shot) seem more "open" and "warm" than subjects with closed-down pupils. Shooting with strobe lights in a dimly lit studio is the way to go for the wide-open pupil look. This is because the strobes fire and shut off before the pupils have a chance to close down. Hot lights, which provide a constant bright-light source, close down the subject's pupils.

For beauty shots, you may want to see more of the iris (the color part of the eye).

The point is to pay attention to the size of the pupils; it will affect how the subject comes across in your photograph.

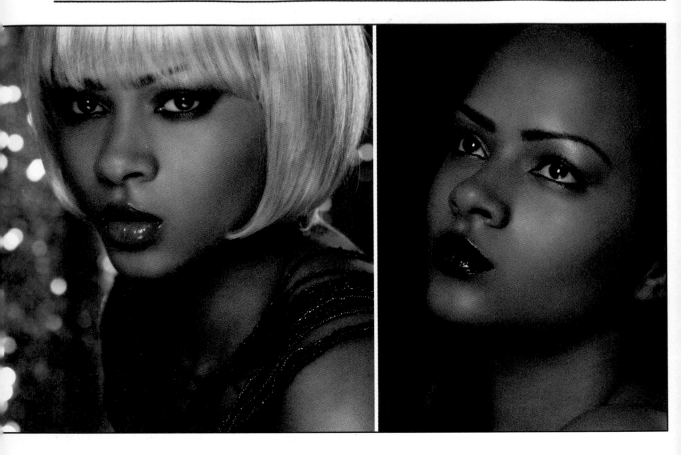

Go For a Total Transformation

Check out these two photographs. Which model is your favorite? Look into the eyes in each photograph for a while and then come back here.

We actually already know which one is your favorite, because it's the same model.

We've included these photographs, taken within an hour, to illustrate the dramatic transformation of adding a wig, changing the makeup, replacing the background and changing the model's clothes.

Taking these types of "total transformation" shots is not only fun and creative, but it's a great way for a model to show a booking agent how she can look totally different for different clients.

Of course, there is another difference in the photographs. In the picture on the left, the model has an "attitude"; in the picture on right, she looks more peaceful.

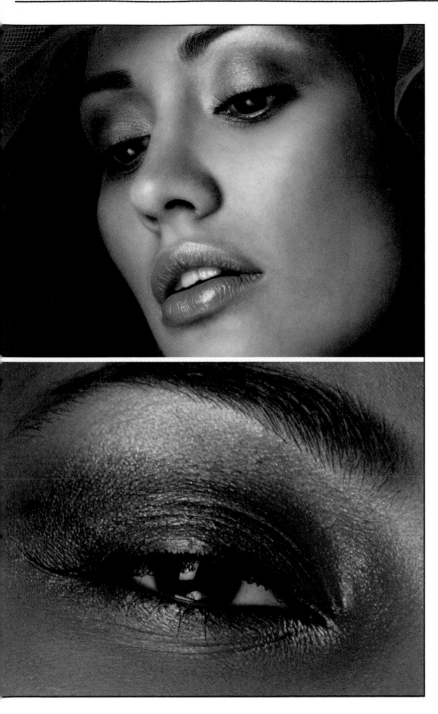

Master Makeup

Look at the masterful eye makeup in these photographs. In both cases, a professional makeup artist was hired to create the high-fashion look.

If you are serious about being a pro, get serious about working with a professional makeup artist. Sure, some models can do their own makeup, but a pro can usually create any look—and feel—that you are trying to achieve.

Of course, before you hire a model, ask him/ her if (s)he does makeup, and ask to see examples.

On a budget? Offer the makeup artists some prints or digital files of the finished work in exchange for his or her services.

You might be able to find a skilled makeup person at the makeup counter in a department store, especially when the store is promoting a particular brand of cosmetic.

You can also find makeup artists, as well as models, on industry web sites, including Model Mayhem (www.modelmayhem.com) and One Model Place (www.onemodelplace.com).

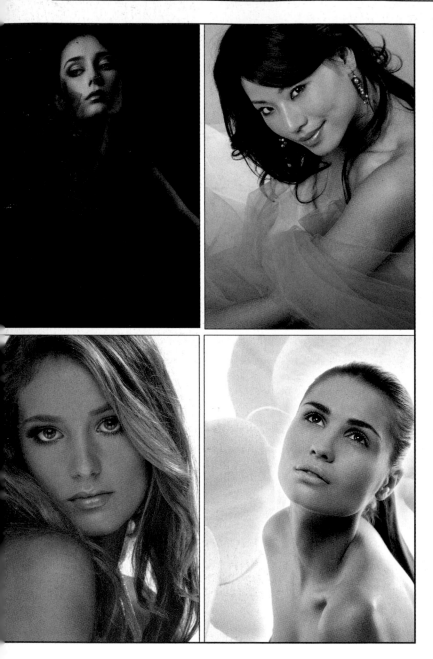

Understand Body Language

Sure, the subject's face is important in a photograph. But body language is also important, as it helps to convey the mood and feeling of the subject. This is especially important in advertising photography, where the subject needs to connect emotionally with viewer.

Check out the body language in these photographs. According to my friend Dr. Richard Zakia, author of *Perception and Imaging*, it suggests (clockwise from top left):

- Sophistication and self-confidence, as in "Look at me; I'm above it all." Her eyes look downward and her head tilts back as she looks off to the side.

- Playfulness and flirty. The model is making eye contact and smiling, and her pose is very relaxed.

- Thoughtfulness and dreaminess. The upward gaze and somewhat angelic expression creates this contemplative look. The model's slightly parted lips activates the expression, and her dropped shoulder suggests openness.

- Youth and innocence. The sensual shoulder projection and prominent eyes create a warm, loving look.

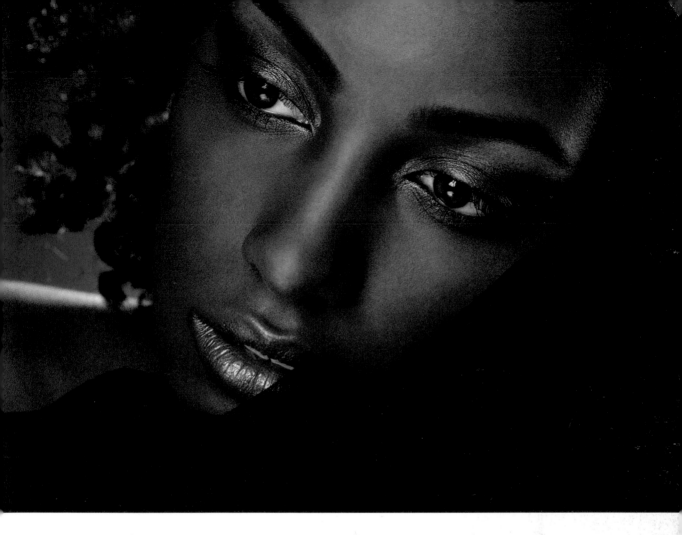

Part VI

Oh, the Details

Details can be the difference between a great shot and a shot that makes you say, "Ahhhhh, how could I have missed that little detail?" This chapter is all about reminding you to check out the details before you press the shutter release button.

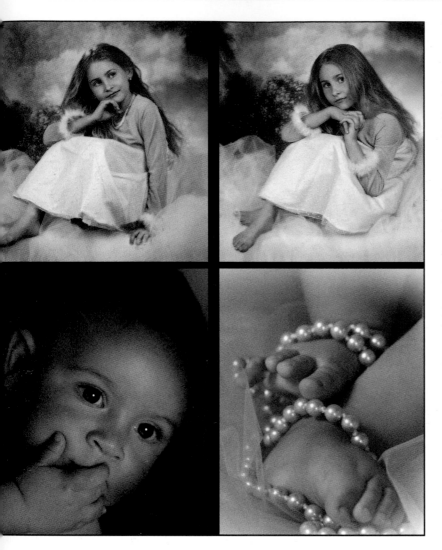

Watch the Hands

Sometimes, photographers get so caught up with controlling the light that falls on a subject's face that they overlook another important part of a portrait: the subject's hands.

Compare the hands in the top two photographs. In the picture on the right, the subject's right-hand pinky is sticking out in an awkward position. In the picture on the left, the right hand is in a much more flattering position.

Most mothers tell their kids to keep their fingers out of their mouths, but as you can see in the photograph on the bottom left, rules are meant to be broken.

Feet are important, too. Keep an eye on them for a head-to-toe perfect portrait.

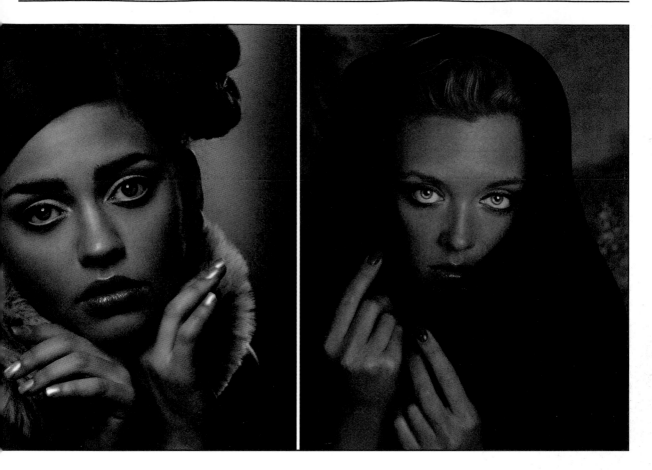

Notice the Nails

Details can make or break a picture. This definitely includes fingernails.

In the photograph on the left, the color and reflectivity of the girl's fingernails are distracting. Sure, we could fix the color in Photoshop, but the washed out detail is nearly impossible (or very time consuming) to fix.

Check out the girl's nail polish in the photograph on the right. Now that's more like it! See how it almost matches her lipstick.

Discuss nail polish with a model before (s)he shows up. Also ask your models to get a manicure before the shoot.

It's a good idea to have nail polish remover on hand … as well as several different types of nail polish.

During the shoot, watch out for reflections on fingernails.

Got toes? If toes will be in your photograph, apply the aforementioned tips to toenails.

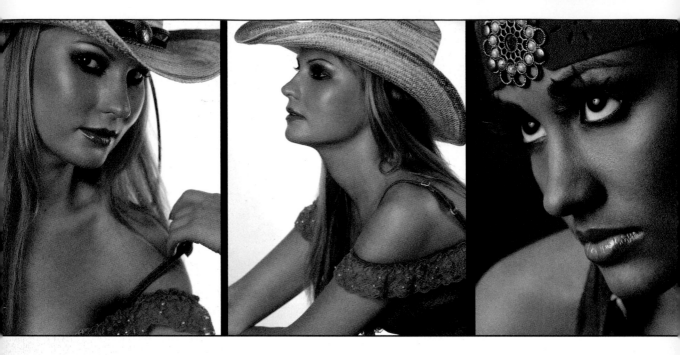

Pay Attention to the Nose

What do the left and center portraits have in common … other than a good model and a cowboy hat? That's right! Vered paid careful attention to how the nose looks in both images.

In the picture on the left, the model's cheek acts as a background for the nose. In the picture in the middle, the nose is perfectly profiled.

In portraiture, it's a good idea to follow one of these two techniques. Try to avoid photographing a model in such a way that the nose is just slightly protruding from the cheek—as shown in the picture on the right.

Hey! I love the picture on the right. It's a great shot! I am telling you this for a reason: Rules … all rules … are meant to be broken.

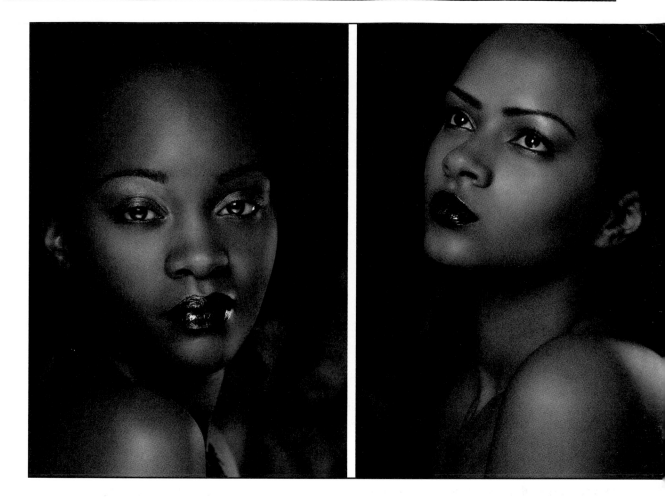

Watch the Lips

Compare the model's lips in these portraits. In the picture on the left, there is a bright reflection from the studio lights. In the picture on the right, the model was posed and the lights were positioned in such a manner that virtually all reflection is eliminated from the lips.

Sure, Photoshop's Clone Stamp or the Healing Brush tool could be used to remove the reflections in the first picture, but this example illustrates the importance of minding details during a shoot. After all, would you rather be shooting or editing?

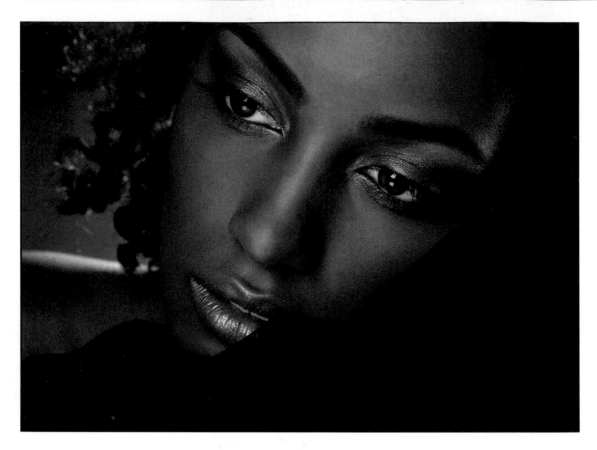

Gain the Model's Trust

Gaining the model's trust is another important detail that will come through in your photography.

Below are a few suggestions for forging trust. While they apply to both male and female models, we'll refer to females only to avoid repeatedly writing "his and her."

First, your behavior must remain 100 percent respectful and professional. Comments such as, "You look hot!" are suggestive and don't go over well during a shoot. Yet, you can be appreciative and say something like, "This looks great; we're going to have a really good shoot today."

Make sure the model is comfortable. Ask her if she is warm or cold and if she wants something to drink.

Respect the model's boundaries. Don't push her to do anything that is uncomfortable or unnatural for her.

Pay attention! Be aware of the model's energy level. If she is getting tired, take a break.

If you are using a makeup artist and stylist, tell the model what a great job the person did. Indirectly, you are telling the model that she looks great, and this boosts everyone's spirits.

Finally, always keep a positive attitude. This will show on the model's face and in her body language.

© Michael Creagh

Part VII

The Beauty of Black and White

Several months before this book went to press, I was
reading a photo magazine and noticed the outstanding
work of Michael Creagh. Two minutes later, I was writing
him an email, asking him if he'd like to contribute to this
book. It took about tens minutes for Michael to bounce
back a *Yes!* Lucky bonus for you…and us! We know you
will enjoy his work and insights.

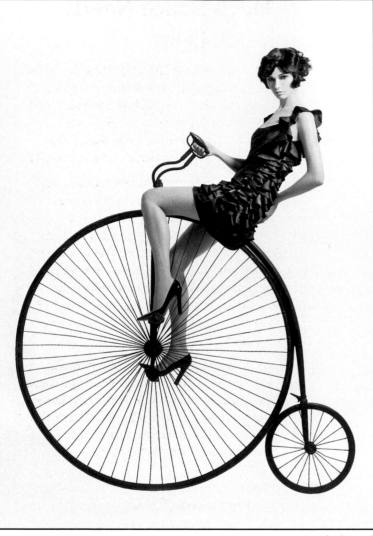

© Michael Creagh

Good Production Trumps Lighting

It's not the lighting that makes this shot successful; it's the production.

Riding a bicycle like this one is not a skill that top agency models are trained to do. Finding the bicycle was difficult enough!

In reality, two big guys held the bicycle up while the model used steps to get on it. She didn't peddle anywhere. Later, using Photoshop, I removed the two men.

Lighting the model was accomplished with the main light high at a 45-degree angle coming from the right. It was an undiffused Profoto beauty dish on a Profoto Strobe. It is a punchy light, and you can see its effect on her face and on the ruffle of her clothing before it falls off on the legs.

A great model, props, hair and makeup go a long way to making your lighting, and therefore your photos, look good.

On the opposite side, at a 45-degree angle, was a large softbox acting as the fill light. The background was lit separately, which presented an entirely different set of challenges. Those are covered next in the Much Space Needs Much Light section that describes a trapeze photo.

Michael Creagh: http://michaelcreagh.com

Model: Valya M at MC2 Model Management, New York

Job: Susana Monaco Resort Catalog

Camera: Hassleblad H3D 39 MegaPixels, 80mm lens

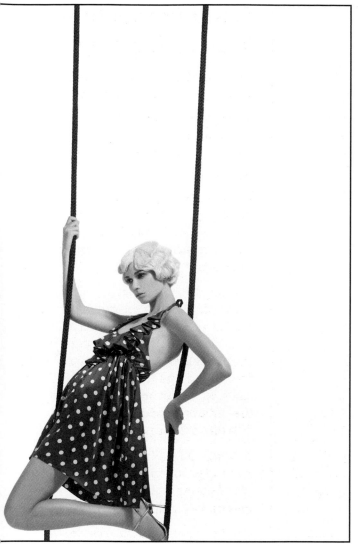

© Michael Creagh

Much Space Needs Much Light

The most difficult part of lighting this photo was dealing with the immense super-white background. Photographed using an actual free-standing trapeze unit, the model covered a huge area of space during the shoot that included twenty different outfits.

The background was 26 feet high and 26 feet wide. It required six studio strobes with umbrellas: three on each side at various heights ranging from low to high. Fortunately, the background on a smaller set could be accomplished with two lights with umbrellas: one on each side of the backdrop. Four lights, staggered at higher and lower positions, will give you a more even light.

Again, lighting the model was accomplished with the main light high at a 45-degree angle coming from the right. It was an undiffused Profoto beauty dish on a Profoto Strobe. On the opposite side, at a 45-degree angle was a large softbox acting as the fill light.

Michael Creagh:
http://michaelcreagh.com

Model: Valya M at MC2 Model Management, New York

Job: Susana Monaco Resort Catalog

Camera: Hassleblad H3D 39 MegaPixels, 80mm lens

Using a Light in Your Frame

This is much easier than you think. Just place the background somewhere and experiment.

The light does not have to super bright, but set it in the same ballpark as your main light. So, if your main light is a strobe, your light in back should also be a strobe.

Here I used a fog machine in between the model and the light to create a more diffused backlight. You will have to play with the effect, but I enjoyed a very light film of fog to balance out the heavy burst of light that otherwise created an unsightly bright blob.

I think another, yet unhealthy, method for this effect is a big puff of cigarette smoke in front of your back strobe.

The second trick to this lighting technique is creating the illusion that the back light is also the main light. It is not. To create this look, the back light is positioned pretty far from the model and has a minimal effect.

I positioned a Mola Reflector dish on a Profoto strobe to the left side (and a touch behind the model) to create the illusion it is the same light. This allowed me to have a punchy light on the model but still illuminate the clothing for the designer's catalog.

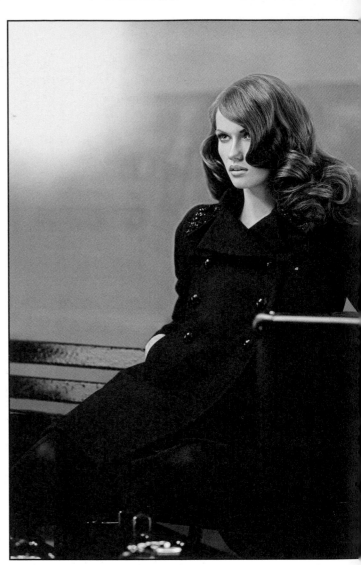

© Michael Creagh

Also, as the model tried different poses, I could continually adjust my main light to suit her while keeping my composition consistent with the back light and suitcases in front.

Michael Creagh: http://michaelcreagh.com

Model: Kate at 1 Management, New York

Job: Susana Monaco Fall Catalog

Camera: Hassleblad H3D 39 MegaPixels, 80mm lens

Main Light Selection

Many of my photos are produced with some type of beauty dish on a strobe flash. They are punchy and show off a face with good bone structure. They're also quite portable on a set. You can move them quickly on the end of boom or just put them on a normal light stand.

Using a single light with a beauty dish in front of an unlit white backdrop (positioned about ten feet behind the model) will give you a classic grey background fashion shot.

Among my favorite lighting setups is an undiffused Profoto beauty dish—or a bigger parabolic Mola Reflector dish—with a diffusion panel on the front. This shot was with made with the Mola, a soft fill light, and a back light.

The point is not to run out and buy one, but to experiment and find lighting that you love to work with. I love window light, direct sunlight, low light in the shadows, eight-foot-high softboxes, neon lights on the street … even on-camera flash; they all create different moods and present your model uniquely.

One of my dear photographer friends creates the most beautiful light with a small softbox with a grid. Others create an entire wall of light.

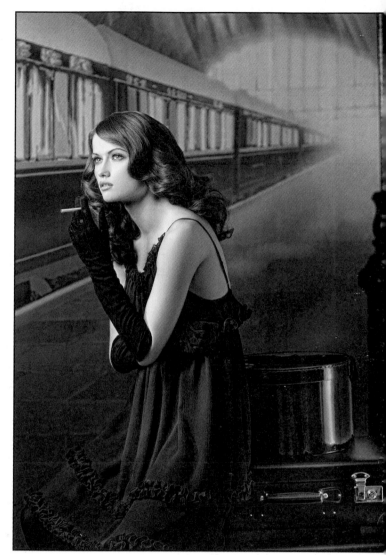

© Michael Creagh

Everyone's face takes differently to light, so experiment on every subject. Create mood. And don't be afraid to take bad pictures; just be sure to create some good ones by the end of the day.

Michael Creagh: http://michaelcreagh.com

Model: Kate at 1 Management, New York

Job: Susana Monaco Fall Catalog

Camera: Hassleblad H3D 39 MegaPixels, 80mm lens

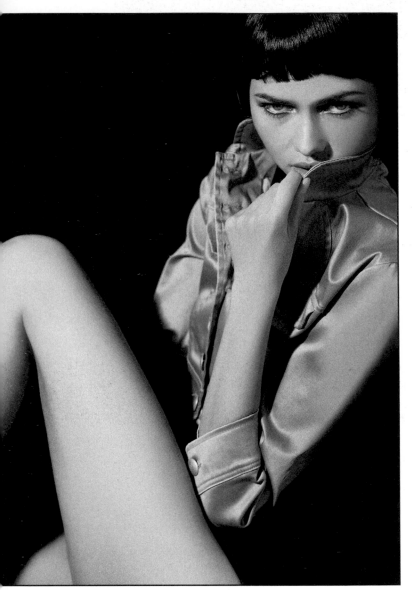

© Michael Creagh

Have a Great Model

Nothing makes you look like a master of lighting better than a gorgeous model.

During my first couple of years as a professional photographer, I worked really hard to create softer and softer light to make normal pretty girls look like top models. For the most recent several years, I have been working on building my relationships with top agencies to get amazing faces that can take any light.

For example, you set up your lighting and your backdrop and you photograph a friend in black and white. You show people and they say, "Wow, I like your photography; it's great." Now, you don't change your lighting … for better or worse, but you put a gorgeous model in the same scene, and people are like, "Wow, you are amazing at lighting! You really understand beauty."

For this shot, I used one 1000-watt Profoto Tungsten light without any alterations, diffusion or attachments. But I could have lit her with a spotlight from Home Depot for a similar harsh sunlight-type effect.

The light was slightly above her and to the left. I draped black sheet over the couch she was sitting on and clipped the ends of the sheet to light stands, so it would be above her head. The result is dramatic and beautiful … mostly because this is a terrific model.

Michael Creagh: http://michaelcreagh.com

Model: Marta S at 1 Management, New York

Job: Magazine Cover

Camera: Canon 1DS Mark III 21 MegaPixels, 85mm 1.2 lens

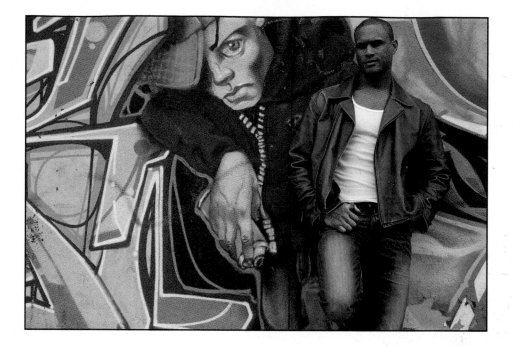

Part VIII

Tools of the Trade

This chapter illustrates how you can use an accessory camera flash (or two or three), combined with affordable reflector/ diffuser kits, for professional studio lighting. We're giving you the basics here. It's up to you to create your own unique technique and style.

By the way, you'll notice we take our flashes and our diffusers on location to the Explorers Club (where Rick is a member) in New York City for pictures in the Club's Trophy Room. The trophies shown have been in the Club for decades; neither of us have ever hunted, and we don't promote it.

In fact, Rick is an ardent conservationist. He's written books on marine conservation (including *Seven Underwater Wonders of the World*) and has served as president of CEDAM International (Conservation, Education, Diving and Marine Research) for more than 20 years.

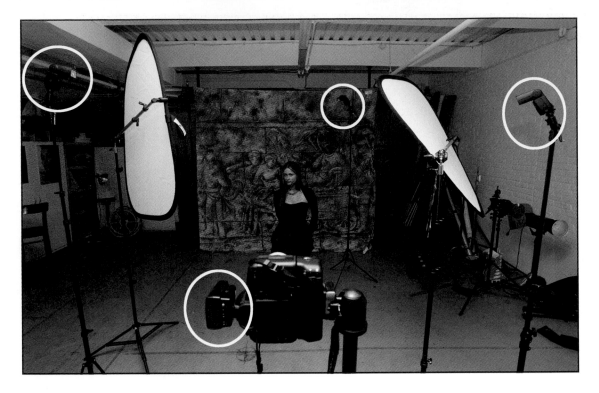

Basic Diffuser Setup

The beauty of using diffusers and camera flashes is that they can help you produce portraits with a nice soft touch. Here's a behind-the-scenes look at a basic setup for diffusers/ flashes.

On the left is the main light source, placed above the subject's eye level and at a 45-degree angle to the subject; it's set at full power. The flash is placed about three feet behind a diffuser. The diffuser increases the effective size of the light source and softens it.

On the right is the fill light, placed above the subject's eye level and at about a 45-degree angle to the subject; it's set at –1/3 power. It is also placed behind a diffuser.

In the background is the hair light, positioned above the subject's head and set at –3 power. It's angled downward and to the side of the set so that the light does not spill onto the subject's face.

Depending on the effect you are trying to create … and the reflectivity of your subject's clothes … you'll want to vary the +/– settings on the flash units. That said, the aforementioned settings will pretty much hold as standard.

All flashes are fired remotely from a wireless controller that is mounted in the camera's hot-shoe.

These diffusers are from FJWestcott. The flash stands with cold-shoe adapters are from Bogen Imaging. The wireless transmitter and flashes are from Canon. (For more information on wireless accessories, see Chapter 9: Unleash Yourself.)

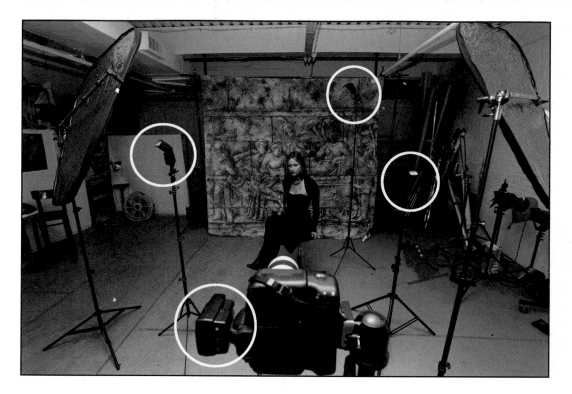

Basic Reflector Setup

This behind-the-scenes photograph shows that the flashes and reflectors are placed in the same positions as flashes and diffusers on the previous page.

Like diffusers, reflectors increase the size of the light from a camera flash. However, the light produced from bouncing light from a camera flash into a reflector has a strong/ harsh quality. There are times when this may be desirable.

The gear in this setup is from the same manufacturers that are mentioned on the previous page.

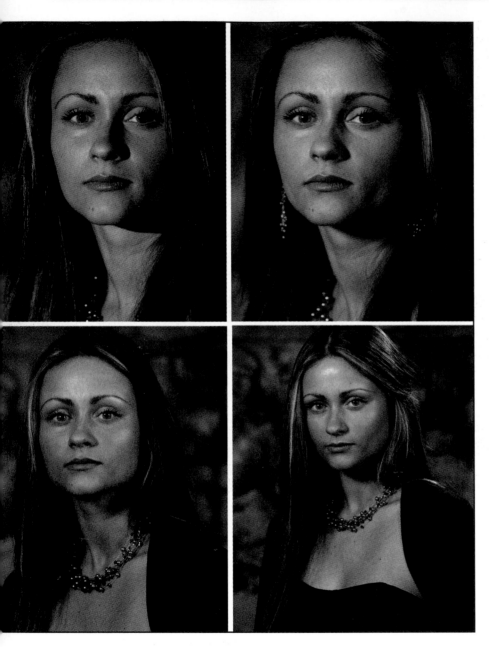

Basic Flash/ Diffuser Portraits

Here's a look at four basic lighting effects you can create with a flash/ diffuser setup. Left to right, from top:

• Main flash, no diffuser—The strong shadows make this shot our least favorite. It's an example of why you really need to shoot with more than an off-camera flash.

• Main flash fired though a diffuser—Notice the soft shadow on the model's left side (camera right).

• Main flash and fill-light fired through a diffuser—Nice, too. See how the fill-light illuminates the shadow area. It's more effective at minimizing shadow than the reflector.

• Main flash and fill-light fired through a diffuser and a hair light added—It's quite nice. But there's more to come. Read on!

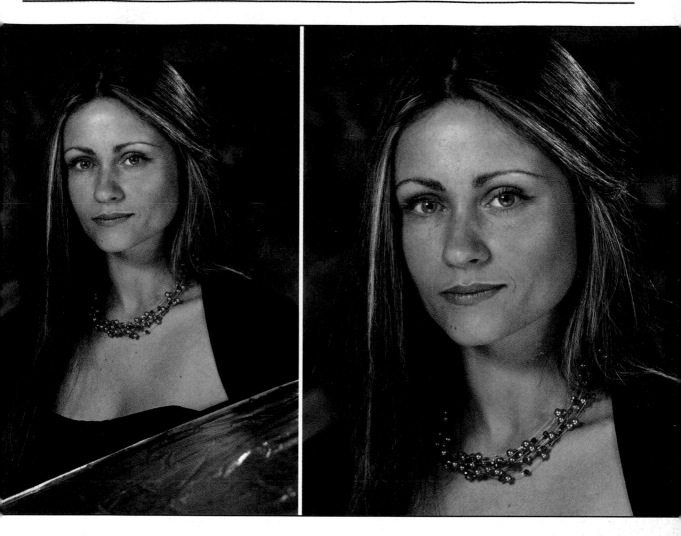

Flash/ Diffuser with Reflector Keeper

Using the three-flash/ diffuser setup described on the previous page, you can position a reflector under the model's face to eliminate the shadow under her chin. To illustrate this technique, the reflector is not cropped out of the full-frame picture on the left.

The picture on the right is the cropped version of our keeper. We did a bit of retouching to the photograph. Can you see where? Look closely. The answer is just two pages away.

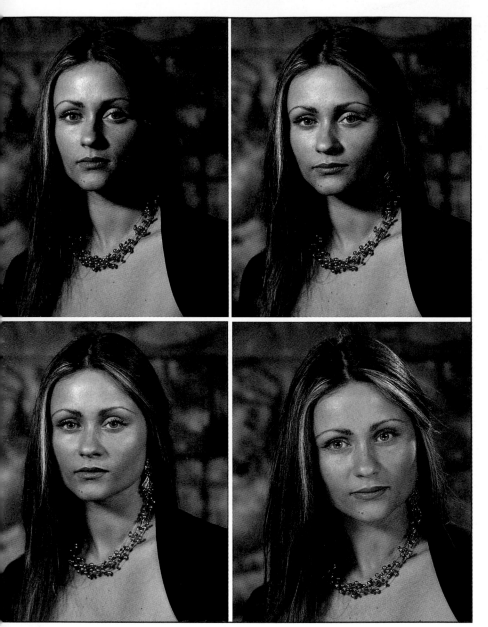

Basic Flash/ Reflector Portraits

Here's a look at four different lighting effects you can create with a flash/ reflector setup. Notice that the strong intensity of light produces pictures that are less soft than the pictures you get by using a flash/ diffuser setup. But they are still nice! Left to right, from top:

- Main flash, no reflector— Again, strong shadows make this shot our least favorite in this group.

- Main flash bounced off a reflector—Notice the shadow on the model's left side (camera right).

- Main flash and fill-light bounced off a reflector—See how the fill-light illuminates the shadow area; it fills this space more effectively than the reflector.

- Main flash and fill-light bounced off a reflector and a hair light added. Quite nice!

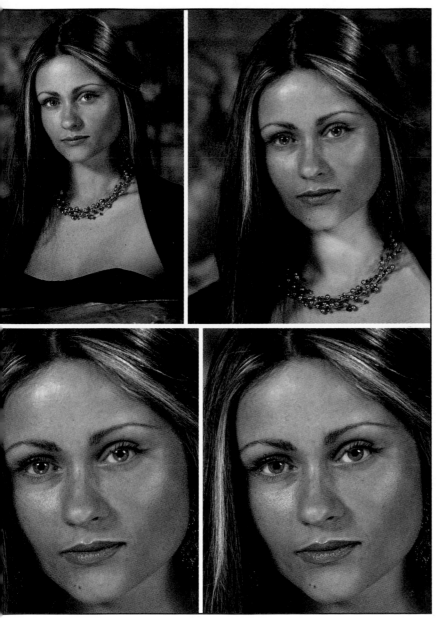

Flash/ Reflector Keeper

As in the diffuser shoot, we used a three-light setup (described on the previous page) for the reflector shoot and positioned a reflector under the model's face to eliminate the shadow under her chin. To illustrate the technique, the reflector is not cropped out in the full-frame picture on the top left. The cropped version on the top right is our favorite from the flash/ reflector shoot.

The bottom two pictures are cropped versions of our keeper. Can you see the difference between the two? Take your time.

Check out the eyes. In the picture on the left, you'll see the reflections of three lights in the model's eyes. It looks kind of weird, eh? In the picture on the right, two of those reflections were removed in Photoshop (using the Clone Stamp tool). You might ask, why not remove all the catch light? Well, catch light is great; it makes the eyes sparkle.

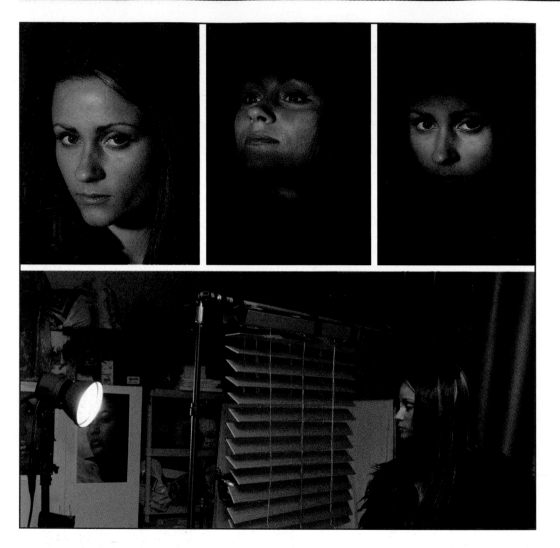

Creative Lighting Accessory

Sure, you can spend thousands of dollars on studio light gear that will help you get great shots. But for about $30, you can pick up a cool lighting accessory: Venetian blinds. These everyday window coverings will help you create great lighting effects even when you are shooting with only one light.

First, position the blinds (taped on a reflector/ diffuser stand in our behind-the-scenes photo) between the light and the model. Adjust the opening of the slats to vary the lighting effect. Also vary the distance (three feet for our photo) between the light and the blinds.

The image on the left is a straight shot; no blinds were used. The other two images show the effect of varying the size of the openings in the blinds.

This is an evolution-of-a-photo-shoot technique. You need to experiment to get the desired effects.

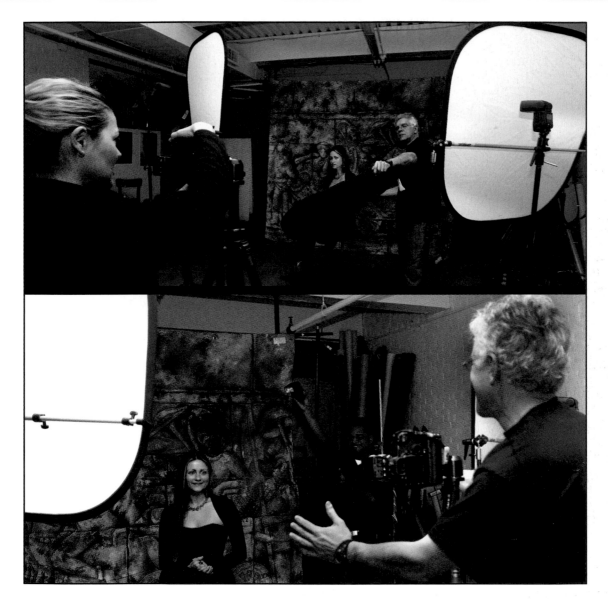

Mo' Behind-the Scenes Photos

In the top picture I'm hard at work positioning a reflector for our flash/ reflector keeper shot. In the bottom picture, I'm following one of my favorite photo philosophies: *Keep the subjects interested in the photo shoot by keeping them engaged.*

Talk to your subjects. "Silence is deadly" during a photo shoot; it's my working motto.

That's Hector Martinez, our assistant for the day, holding the hair light in the background. Hector took many of the behind-the-scenes photos in this book. Thanks, Hector!

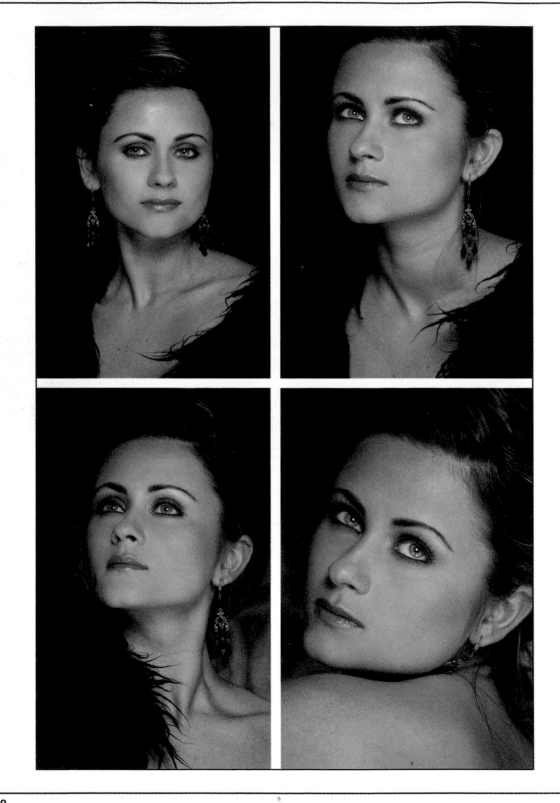

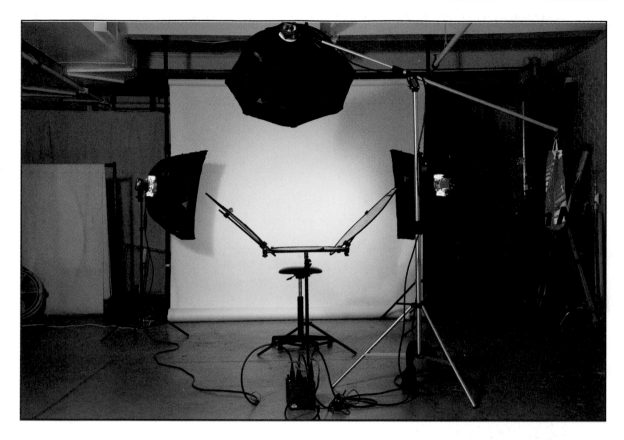

Try a Triflector

The portraits on the left side of this spread were taken with the lighting setup you see above.

At first glance, you might think there are only three types of light here: two side lights; strip lights with a grid (to direct the light for pleasing side highlights); and a main light—an octodome, also with a grid—positioned in front of and above the model.

Combined, these three light sources produce beautiful lighting. Yet they can also produce shadows beneath the subject's chin and nose … as well as to the side of the nose and around the eyes.

That's why a triflector, the device you see in the middle of the behind-the-scenes shot, was also used. The three adjustable reflector panels fill in those shadows by reflecting light from the sources. By doing so, this device functions as a fourth light source … without actually producing new light.

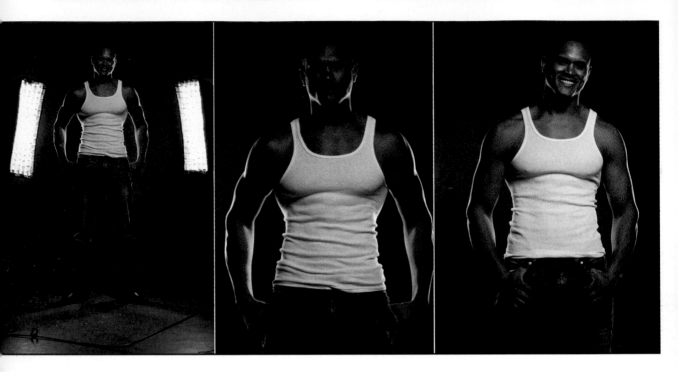

Variations on a Theme

This series of photographs illustrates creative sidelight placement.

The left image shows the placement of two strip lights with grids: to the side and slightly behind the subject. This setup produced nice rim light around the model's arms, as shown in the middle photograph. The subject's face is not defined, but that's okay in some cases, depending on the effect you're trying to achieve.

The photograph on the right illustrates what happens when a front light is added. Now the model's face is more defined. The right photograph on the opposite page shows the placement of that light as well as the sidelights.

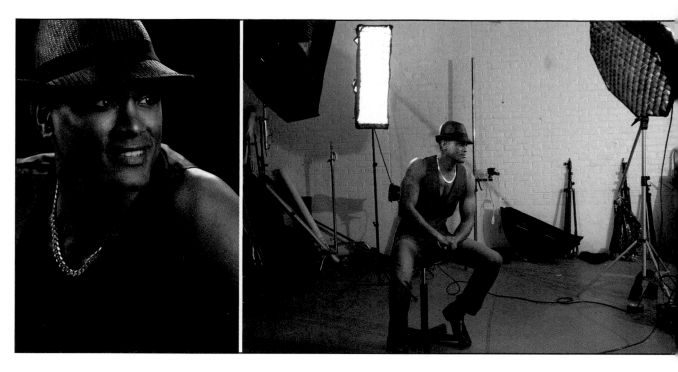

The photograph on the left (above) is yet one more variation on a theme. The hat, black vest and silver chain change the mood of the image. More importantly, notice the catch light in the model's eyes. In this portrait, the model is looking at the main light source: the octodome.

Jump Into Creative Outdoor Lighting

Throughout this book are dozens of tips and examples for controlling light in an indoor studio. Well, you can use the same lights, reflectors and other accessories outdoors, too ... as illustrated by the photographs on this spread.

In the top photograph on this page, a remote flash was mounted on a stand and placed in a mini-octodome softbox. This setup was used to freeze the action of the model jumping and generate a dynamic photograph. Compare the contrast and detail in that image to the photograph on the bottom, which looks flat because the day was overcast. Overcast days produce flat lighting.

The pictures on the opposite page show (clockwise, from top left): flat, overcast day lighting; brightening effect of a reflector; enhanced contrast created with a flash; and a remote flash setup.

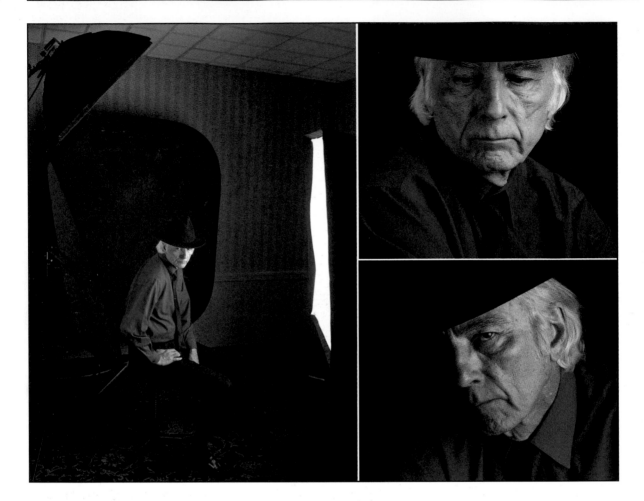

Just Takes One

It doesn't get much simpler or easier than this: A constant-light main light (on the right side of the image on the left), a reflector (on the left side) and a collapsible background. For the portraits on this page, the light positioned above and to camera left is turned off.

This type of simple setup can help produce some beautiful portraits. The top photograph shows the effect of using the main light and the reflector. As you can see, the reflector bounced some of the light from the main light onto the opposite side of the model's face. It's an okay shot—one that shows the distinctive features of the model.

The bottom shot, however, is my favorite from the session. It shows the effect of using only the main light; the reflector was moved out of position. I like the way the deep shadow on the model's face adds a sense of drama to the image. I also like the way the model is making direct eye contact with my lens … and viewers of this image.

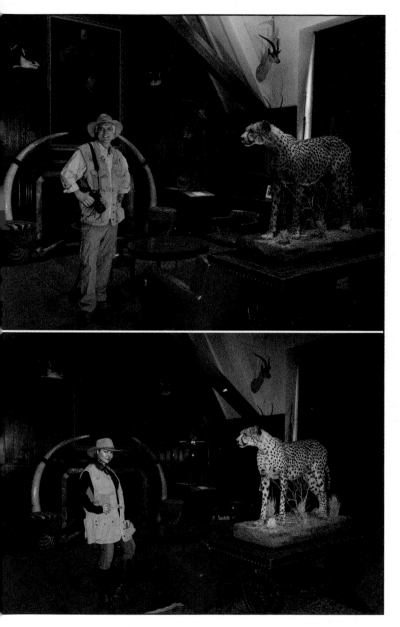

Combine Flash and Ambient Light

Vered and I—with our assistant Hector Martinez—had a blast creating the lighting setups for the photographs on this page. Vered was a good sport, donning my safari jacket and hat as part of the photo fun.

The lighting for both photographs here (taken with a Bogen tripod-mounted Canon 5D Mark II and a 17-40mm lens set at 20mm at f/8) was basically the same. One stand-mounted Canon Speedlite 580EXII was fired through a stand-mounted Westcott diffuser that was positioned above eye-level and off to camera right at about a 45-degree angle. A similar flash/ diffuser setup was positioned to camera left.

A third flash was positioned on the red couch (out of camera view) and pointed toward the rear wall to illuminate the background. Hector held a fourth flash below eye-level and to camera right to light our faces. All flashes were fired from our hot-shoe mounted Canon ST-E2 wireless transmitter. For the cleanest possible picture, the ISO was set at 100.

Here's the lighting difference in the photographs: In the top photograph, we used a slow shutter speed (1/8 second). This allowed the ambient light (from a large window behind the camera) to illuminate the scene more than in the bottom photograph, for which we used a faster shutter speed (1/60 second).

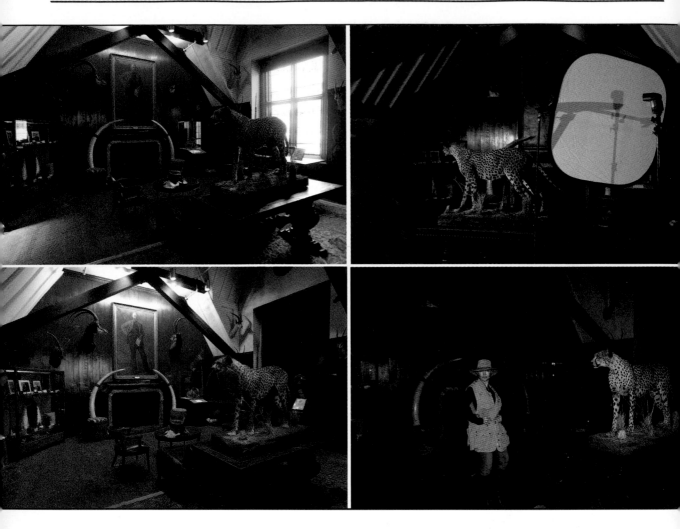

Dealing with Contrast

A primary photographic challenge of this shoot was dealing with the contrast of light in the Explorers Club's Trophy Room.

In the top left picture, the bright light from the window created an extremely wide contrast range. To reduce the range, we lowered the window shade, as you can see in the bottom left picture.

Next we set up our flashes/ diffusers. One setup is pictured on the top right. We varied the flashes' output as well as our ISO and f-stop. And this more-or-less balanced the light from the flashes to the existing room light, which eliminated most of the shadows from our flashes.

The bottom right photograph illustrates the boring type of lighting you'd get with a single, on-camera flash. Yawn …

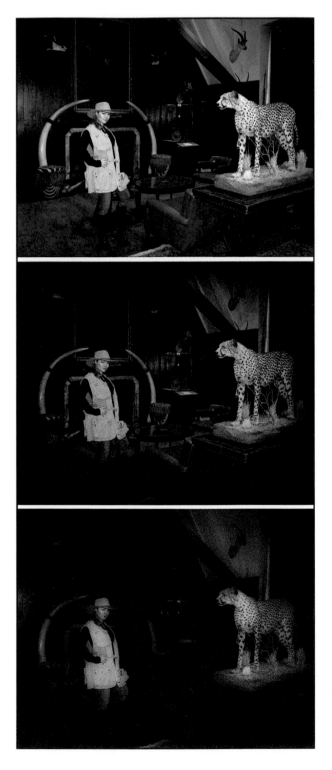

Digital Darkroom Explorations

Rick is a member of the Explorer's Club; he's also a Canon Explorer of Light and a trailblazer of creativity in the digital darkroom.

Here are three examples of his Photoshop handiwork. In all, he uses two filters in Nik Software's Color Efex Pro (www.niksoftware. com) and one Action in Photoshop.

From top to bottom: Black and white conversion (Nik), Sepia Action (Photoshop) and Glamour Glow (Nik).

Karsh-like Images

When I was the editor of *Studio Photography* magazine back in 1979, I had the opportunity to interview one of the most famous portrait photographers of all time: Yousuf Karsh, also known as Karsh of Ottawa. Do a web search on this master photographer to learn more about his exquisite portraits.

During the interview, Karsh told me about the hours and hours he used to spend in the chemical darkroom working on his portraits. My favorite portrait he made is of Ernest Hemingway. In the photograph, you can see every pore on Hemmingway's face. It gives the portrait an almost 3-D effect—ultra reality!

To simulate that super-sharp effect (in my own humble way), I used Nik Software's Silver Efex Pro, which transforms a color image into a black-and-white image. I boosted the grain structure and the contrast of the original image to the point where details were exaggerated.

Find an image you've made and create this intimate and dramatic look. I'm guessing it'll end up among your favorites.

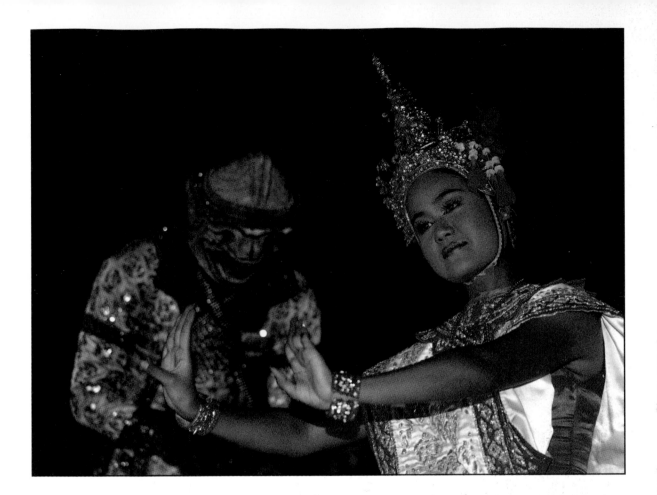

Part IX

Unleash Yourself

Enter the world of wireless flash photography—a world that offers an incredible amount of creative lighting control and flash-photography opportunities. It's a world in which traditionally tricky flash exposures are simplified. Simply put, wireless flash photography makes it more fun to take flash pictures, because it unleashes you from cables that tie your flash to your camera.

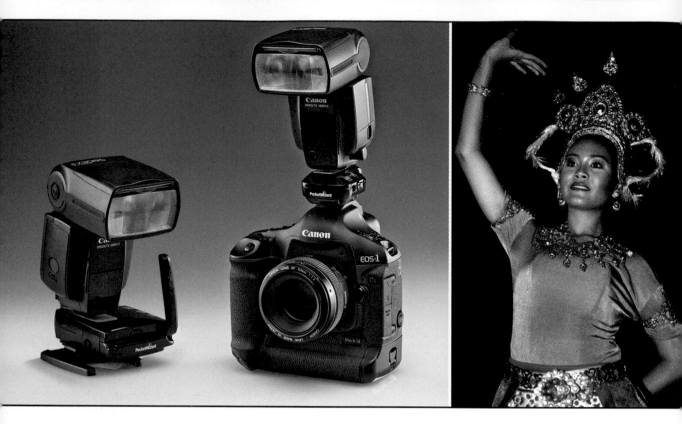

Wireless Tools Expand Your Capabilities

Wireless control of flashes and cameras open up new opportunities to create images that have previously been difficult or even impossible to capture.

With PocketWizard Radios, you can fire flashes off-camera without using cables, which allows you to place lights wherever you need them—instead of where you can get them.

Use single or multiple lights to illuminate a large room for architectural or wedding photography. Or, position a flash hundreds of feet away from your subject … perhaps to light an animal emerging from its burrow as you take a picture with your long lens from a safe distance.

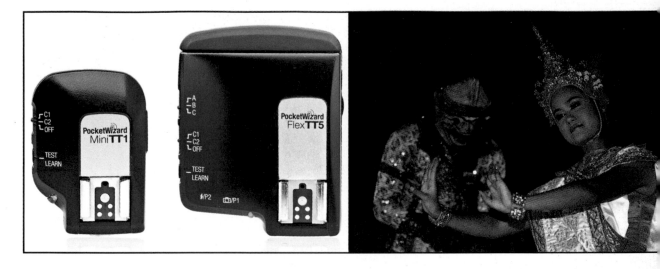

Trigger Your Camera Remotely, Too!

There are also many times when it would be convenient to control your camera without having to be behind the lens. Cable releases have been a staple for a long time, but the distance you can venture from the camera limits you.

PocketWizard Radio Triggers can act as a wireless cable release to fire both camera and flash. Just slide a PocketWizard Radio Transceiver on your camera hot shoe and connect it to your camera with a remote Trigger Release Cable. With a second unit in your hand, match the channels on each PocketWizard Radio and press the "Test" button. The transceiver on the camera will fire the camera from your remote command.

Should you wish to operate your camera in an automatic mode, auto-focus and metering work just as if you were pressing the shutter. Not being tethered to the camera frees you to either better interact with your subject or, in the case of wildlife, to remain at a safe distance.

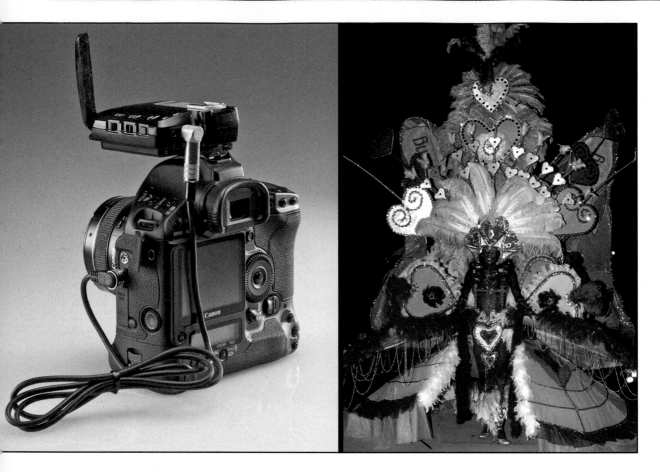

New Features Add to the Fun

In the past, we have been limited to our camera's x-sync speed when using a flash—typically from 1/125 to 1/250 of a second. But now, with the Hypersync ability of the new MiniTT1 and FlexTT5, you can have full power flash at shutter speeds of 1/500 second … and sometimes greater.

Using Canon's eTTL flash system (Nikon support is planned for late summer 2009), high-speed flash sync takes this idea even further. Think of what you could do if you could sync your flash at 1/8000 of a second! Stop the action with shutter speeds that previously kept you from using a standard flash unit.

If you would like to light a subject with a flash while using a wide-open aperture—to keep distracting background elements out of focus—High Speed Flash Sync can solve this problem as well. Your flash unit can provide the light for your subject, and the high shutter speed will allow a correctly exposed (or even underexposed!) background to dramatically separate your subject from the background.

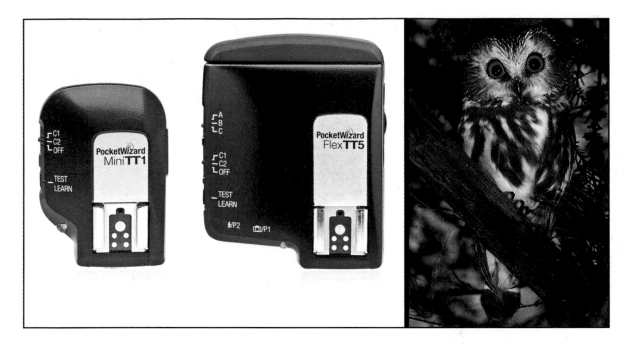

... and It Looks Good, Too!

Again, using Canon's eTTL flash system, you can simply slide the MiniTT1 Transmitter on your Canon DSLR, place each Canon Flash unit in a FlexTT5 Transceiver, match the channels, position your lights and get perfect exposures! No metering, no difficult configurations … just place and shoot. Cool new toys, eh?

By simply adjusting the position and distance of each flash from the subject, you can create lighting ratios and produce professional portraits simply and easily.

Wireless photography using the PocketWizard Radio Triggers can unleash new capabilities that you never thought possible. For more information, visit www.pocketwizard.com.

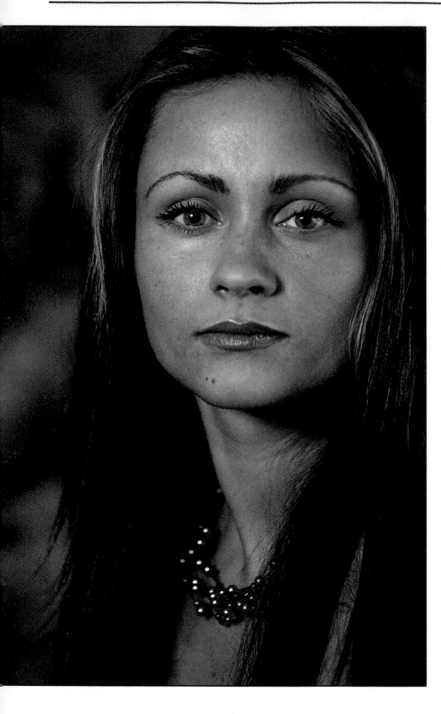

One Flash/ Lighting Kit Combo

If you have at least one accessory flash with wireless control capabilities and a wireless controller, you can create beautiful studio lighting with a reflector/ diffuser kit, such as the 6-in-1 Deluxe Illuminator Reflector Kit from Westcott.

Place the flash behind the diffuser to create a professional softbox lighting effect, and use the reflector to fill in the shadows created by the one-flash setup on the opposite side of the subject. Fire the flash with your wireless control, which mounts in your camera's hot-shoe.

The portrait on this page was created with this setup; although the flash and reflector were on opposite sides of the model. Hey, it's the only behind-the-scenes shot we have to illustrate the setup!

For stronger light, which may be needed to create a portrait with more detail, bounce the light from the flash into a reflector.

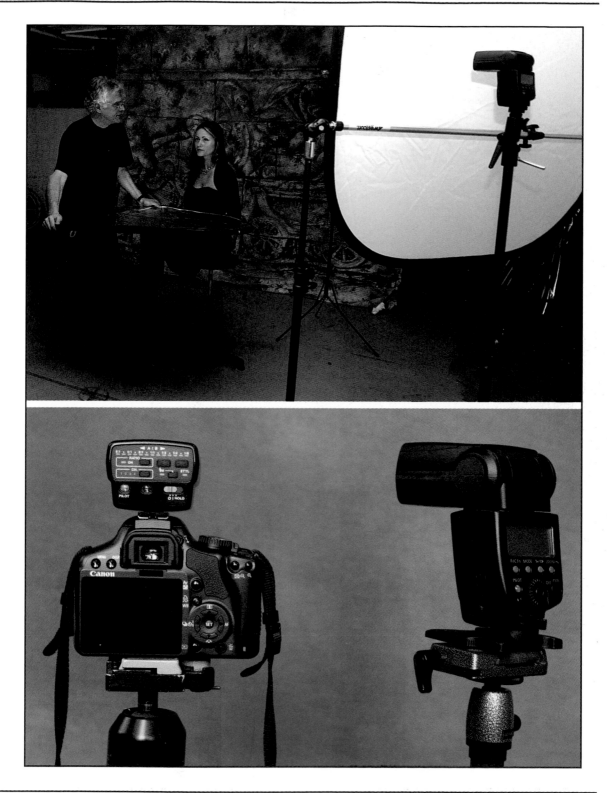

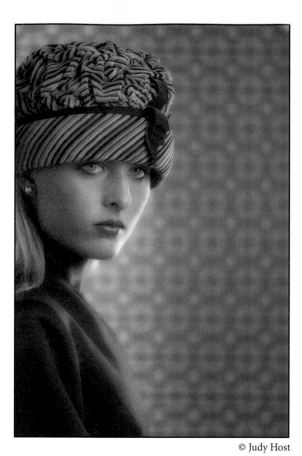

© Judy Host

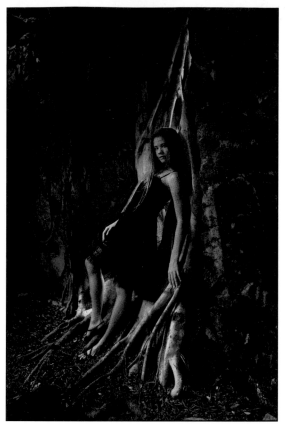

© Eddie Tapp

Part X

With a Little Help from Friends

"With a Little Help From My Friends" and "That's What Friends Are For" are two of my favorite "friends" songs. For sure, we all need friends—and Vered and I are lucky to have such good ones.

In this chapter, some of our photographer friends share a favorite image and photography tip.

The photographs on this page were taken by Judy Host (left photograph) and Eddie Tapp (right photograph). Their tips are only a few pages away.

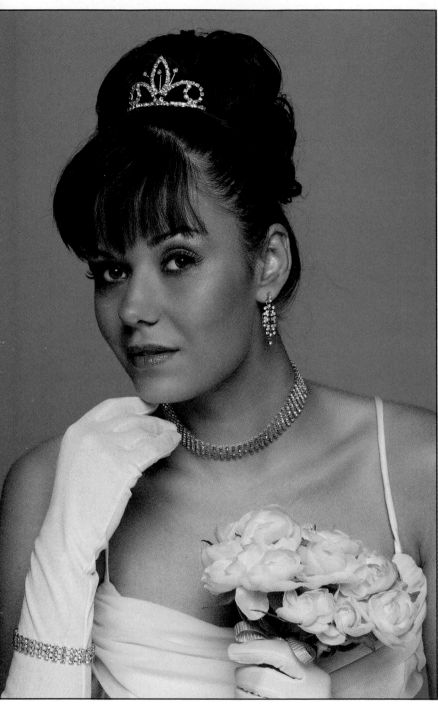

© David Stern

Keep It Simple

My advice is to start your photography work with a simple lighting setup—and to keep it simple. Here, I used one light positioned in front of and above the subject, and I placed a gold reflector on a table at waist level to bounce some of the light into the shadows created by the main light. That's it!

The background is a gray paper sweep. To maintain the color tone of the gray, the model is positioned away from the backdrop.

I used Apple's Lightroom and Adobe's Photoshop CS4 to post process the photograph. And I used a program called Portrait Professional (www. portraitprofessional.com) to retouch the image.

The result is professional … and simple.

David Stern, Photographer

www.davidstern.com

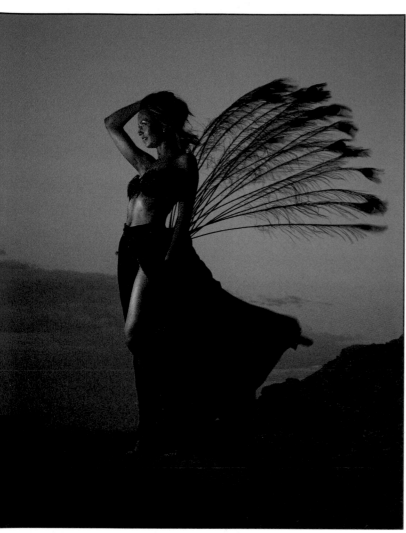

© Eddie Tapp

Work with Twilight

Beautiful twilight is found after the sun goes down in the western sky. You'll also find twilight in the southern and northern sky right at sunset, but the western sky yields the most exciting light—dramatic hues created a few minutes after sunset. There is about three or four minutes of totally blissful twilight in which to shoot.

The key is to wait, watch, test … and shoot.

I took this photograph at Calico Basin near Las Vegas. Model Karie Laubhan is wearing a beautiful outfit designed by Shannon Weller. I used my Canon EOS 1D Mark II camera and set the exposure to 1/80 second at f/9. The ISO is set at 400.

To light Karie, an assistant held a Canon 550EX flash at camera left. I fired the flash with a Canon STE2 Speedlite Transmitter, which was mounted in the camera's hot-shoe.

This picture illustrates how the simple ingredients of wind, light and exposure can be combined to produce a dramatic image. There are no enhancements on this image; it's a straight out-of-the-camera shot.

Eddie Tapp, Photographer
Eddie Tapp Digital Services
www.eddietapp.com

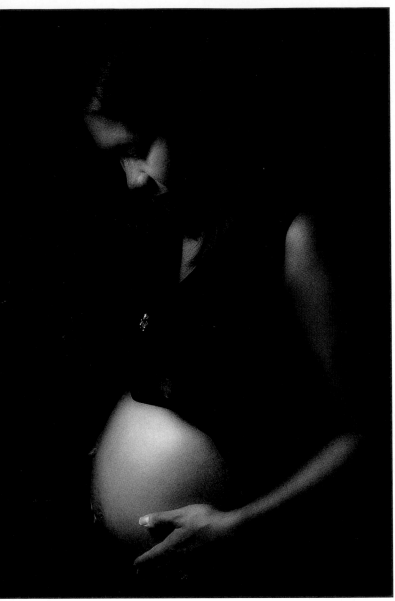

© Courtney Pianki

Light…and Lack of Light

In this image, I wanted to use light … and a lack of light … to showcase the two most important elements in the photograph: the emotion on the mother's face and her pregnant tummy.

We shot this at night. We had no natural light in the studio, and we turned off the overhead lights. The only light source was an accessory flash, which was mounted on a stand and bounced into an umbrella at about 45 degrees to camera left of the subject. We used a dark fleece background, and the model was positioned about four feet away from that background.

A quick tip for studio work: once you begin to feel comfortable with a particular lighting setup, change it a little bit and try something new. It is important to always be testing and learning new techniques. You'll find that it is fun to experiment, and it can help you create stunning photographs.

Courtney Pianki

Pianki Photography

http://piankiphotography.zenfolio.com/

Dramatic Side Light

Creating this photograph with dramatic side lighting was relatively easy. It just requires an understanding of how light works.

I placed a piece of black fabric behind the subject and another piece to camera left. The fabric was there to deaden the light from a single strip light, which was flanked with flags (panels that directed the light). These flags were placed to the right and slightly behind the subject.

David Sparer, Photographer

http://www.pbase.com/dsphoto

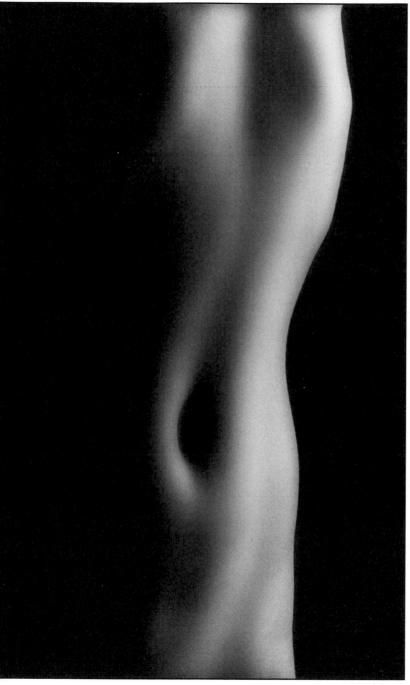

© David Sparer

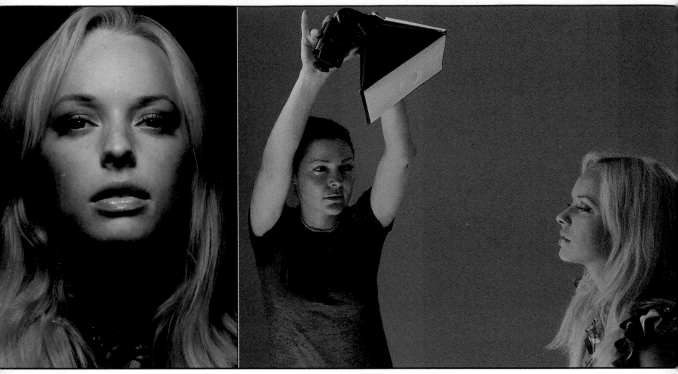

© David Sparer

Soften an Off-Camera Flash

I photographed this model using just one light: a diffused Canon Speedlite that was held off camera and positioned in front of the model above her eye level. The flash was diffused with a LumiQuest Softbox III, which attaches to any flash unit via Velcro strips.

While I was shooting, Rick was taking a behind-the-scenes shot of Vered holding the flash/ diffuser setup in position.

The tip here: If you only have one flash, take it off the camera, diffuse it (to soften and spread the light), and play around with different positions for different effects.

David Sparer, Photographer • *http://www.pbase.com/dsphoto*

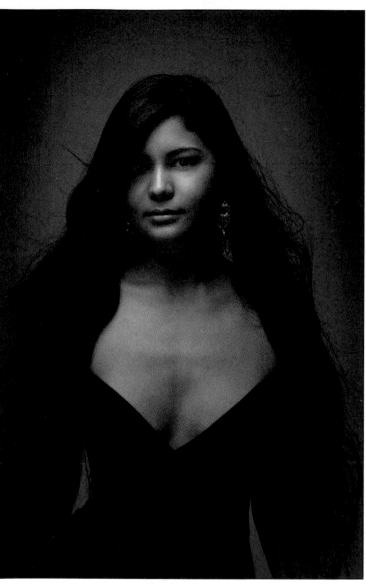

© Douglas Kirkland

A Regal Look

I met Emiko Flanagan when she arrived with my assistant Will Thoren at a gallery opening for my latest book, *Freeze Frame*, in Beverly Hills, California.

I was struck by her great beauty and grace, and I knew I wanted to photograph her.

Later, I found out that she is an accomplished ballerina studying at University of California, Irvine. I find her regal look to be mysterious and haunting.

Here is some tech info on this photograph, a favorite of mine:

- Camera: EOS-40D
- Lens: EF 35-135mm f/4-5.6 USM
- ISO: 100
- Exposure: 1/125 second at f/11
- Focal length: 35mm
- Burned edges in Photoshop to give the vignette look

Douglas Kirkland
www.douglaskirkland.com

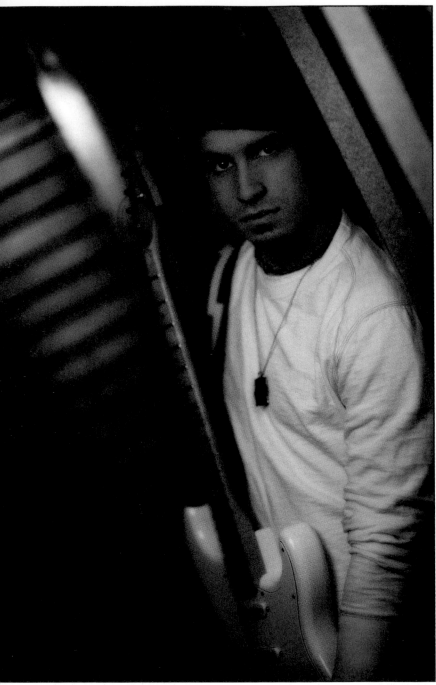

© John D. Williamson

Focus Carefully When Shooting With Fast Lenses

To create the shallow depth-of-field in this photograph, I shot with a Canon 85mm set to f/1.2 and mounted on a Canon EOS 5D body.

Whenever I shoot at f/1.2, I make sure to focus on the eye that is closest to the camera. In fact, this is where I almost always focus for portraits. And with the aperture set that wide, it is even more critical to make sure the focus is right on.

This photograph, by the way, was only possible because of the portability of the Westcott uLites, which allowed me to beautifully light the subject and shoot in a very tight space.

John D. Williamson, Photographer

www.fjwestcott.com

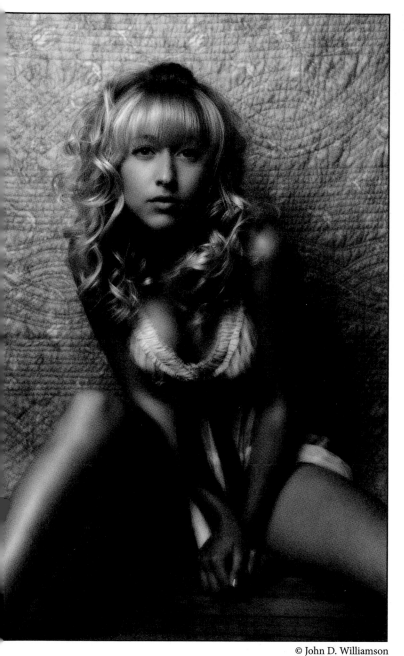

© John D. Williamson

Know the Fundamentals

Good lighting depends on knowing the fundamentals—the basic elements—of illumination. For me, these are the lighting pattern and the lighting ratio. By controlling these two aspects, you can manipulate light to complement any subject.

I used two Westcott Spiderlite TD5s to create this image. The TD5s are a constant light source that uses high-wattage, daylight-balanced fluorescent bulbs. I like using the TD5s for my portraiture because of the soft natural wrap-around lighting that they produce.

My main light, a Westcott 24x32-inch softbox, was positioned just out of frame on the subject's right, approximately one foot above her head. I rotated the softbox into the horizontal position and feathered the light to the front, just past her nose. This position created my lighting pattern.

A fill light was placed seven or eight feet behind me, in front of the subject, and was in a 36x48-inch softbox. It covered the entire scene and was used to control how much contrast (or lighting ratio) was in the image.

For my shoot, I supplied the hairstylist and makeup artist. The talent brought the wardrobe, and we collaborated on choosing what she wore for which shot. Once I saw this dress, I knew exactly what I wanted. She is sitting on the natural hardwood floors in my studio; the background is a blanket that I borrowed from my daughter.

John D. Williamson, Photographer • *www.fjwestcott.com*

Flag It

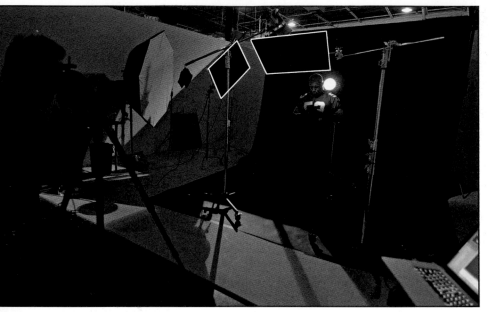

© Scott Kelby

Here's a shot I took while wrapping up the writing for my book *Photoshop CS4 Down & Dirty Tricks*. I needed a shot of a football player for one of the techniques I was demonstrating, so I set up a studio shoot with middle linebacker Blake Johnson from a high school team in Tampa, Florida, where I was working.

I wanted a dramatic portrait, so I shot Blake against a black background, and I used three lights. The main light, an Elinchrom RX-600 strobe, was mounted on a boom stand and positioned in front of Blake. It was placed up high, directly in front of him and angled down toward him at a 45-degree angle. I placed two lights off to the side of Blake. Note: The light on the right is not visible in the behind-the-scenes photo, which was taken by Brad Moore.

I controlled the spill of a three-light setup by using three large black flags. The main flag and the left flag are outlined in white in the behind-the-scenes image. These flags, and the light/ flag off to camera right, were simple 24x36-inch rectangles of black fabric that were used to block the spread of the light.

The flags were an important element in creating this dramatic portrait, and I highly suggest you experiment with them.

That's me on the left, and my tethered computer on the right. When I'm in the studio, tethered shooting is the norm for me.

One more thing: I did post-process the living daylights out of this image, using Adobe Photoshop Lightroom and Photoshop CS4. Hey, whatdaya expect?

Scott Kelby, Photographer, Editor and Publisher of Photoshop User magazine,
Co-founder of the National Association of Photoshop Professionals (NAPP)

www.scottkelby.com

© Scott Kelby

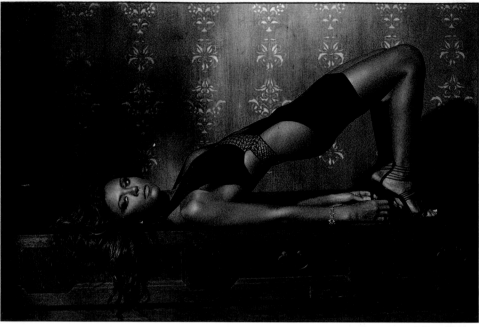

© David Mecey

Have a Story to Tell

To create this photo of the model reclining in the nook, I used three lights.

When lighting almost any subject, I try to *have a story* about the why or where of the light in my pictures. In this particular instance, the model is reclining in what appears to be the room of a large Mediterranean-style villa. To me, this meant the light needed to be dramatic. And though the room in reality is quite small, the elusion is what you make it appear.

In my mind, the subject was being lit from a large shaft of light falling through a set of huge wooden doors from across an enormous room in a mansion.

I began to tell this story by throwing up a key light (main light) from left to right, above and slightly behind a pillar some six or seven feet from where the model was positioned. This created the vignette effect at the edges. To compensate for the fall-off from my key, my assistant hung another light just above and behind her, striking the wall from above to help "sell" the huge broad source that wasn't really there. Finally, to keep the shadows within range, an assistant placed a small strip light (set on very low power) on the floor to help sparkle the wood and keep it from going too dark. This strip light also helped to light up the model's very dark, curly hair.

This is one of my favorite shots, and it is a very popular photograph for the catalogue client for whom it was created. In fact, it was so popular that when the catalog was released, they had so many orders for that particular dress that they had to work overtime to fill them.

David Mecey, Photographer • *www.davidmecey.com*

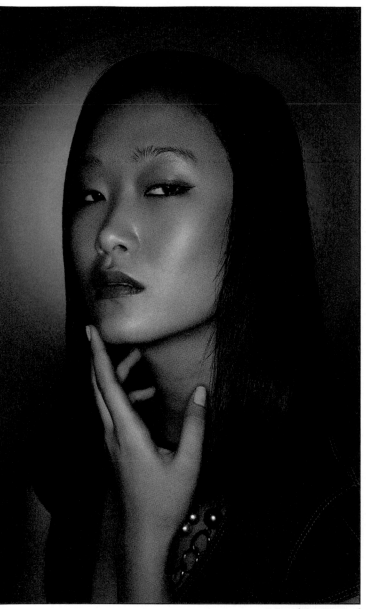

© David Guy Maynard

Add Some Imagination

Sure, you can get some very nice shots using one light source and some imagination. But for that extra "pop" in your portraits, use a second light source to light the background.

Spice up your background by using gels to add color, grids to contour and shape the light, and gobos to direct it. Your imagination is your only limitation.

For this photograph, a standard white fabric was used for the background, and I used my Canon EOS 5D with a Tamron 28-75mm Di lens set at a 70mm focal length. A Canon 580EXll Speedlite was mounted on a small stand and fitted with a red Honl (www.honlphoto.com) gel and a 40-degree Honl grid. This setup was hidden behind the model and fired at the backdrop at 1/8 power to create the red halo. FYI: Honl gels and gobos are a part of the Honl Speed System of light modifiers for use with shoe-mount flashes.

My Canon Speedlite 580EXll provided the primary (main) light in E-TTL mode. This main light was diffused and shaped by the RayFlash (www.ray-flash.com) ring-light adapter mounted on a 580EXll Speedlite.

The camera was set to the Manual mode and set to Spot Metering. Exposure was f/8, 1/100 sec, at ISO 400.

The model, Minyoung Cheong, was positioned about three feet from the background, and the camera was positioned about seven feet away from the background.

David Guy Maynard, Commercial Photographer • www.dmaynardphotography.com

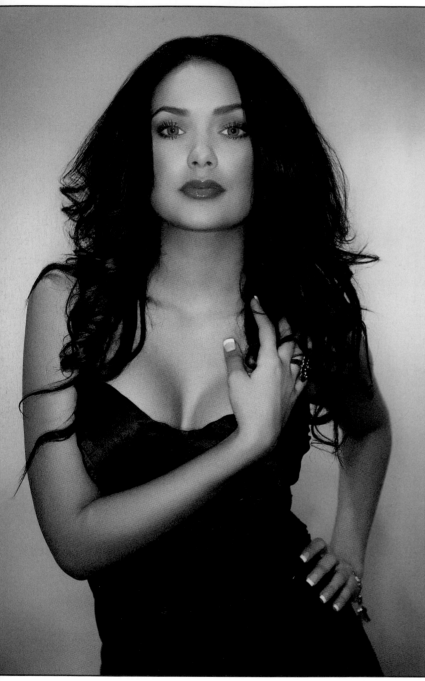

© David Guy Maynard

Carefully Light the Background

Here's a simple tip: Light the background as carefully as you light your subject.

For this portrait of Miss Cuba 2009, Jamillette Gaxiola, I used a Ray Flash ring light on my Canon Speedlite 580EXII for the main light; it was mounted in the camera's hot-shoe.

To light the background, I used two Canon Speedlite 580EX (set at 1/8 power) with red Honl gels and gobos to direct the color light to the background and to block light from the model.

The result of paying careful attention to both the main light and the background light resulted in this beautiful portrait.

David Guy Maynard,
Commercial Photographer

www.dmaynardphotography.com

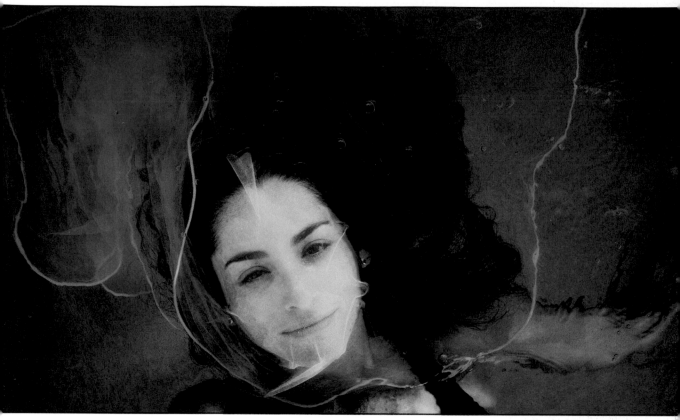

© Bob Davis

Use Your Mind's Eye

Always seek out the light and look for situations in which you can create amazing images. Look for clean backgrounds.

Use your mind's eye to visualize your image, and allow your camera to help you execute the shot and make the vision a reality.

For the photograph on this page, I had an image in mind of a bride, Abby, floating in her wedding gown in the deep blue water of the pool. Abby and husband, Steve, were up for the idea, but not too thrilled about trashing the gown. Fortunately, they were willing to compromise the veil.

The shot worked out great. I used the soft morning light in open shade, and I stood above Abby as she floated in the pool with the veil draped across her face.

Bob Davis

www.lastoriafoto.net • www.lastoriafoto.info • www.davisimpact.com • www.davisworkshops.com

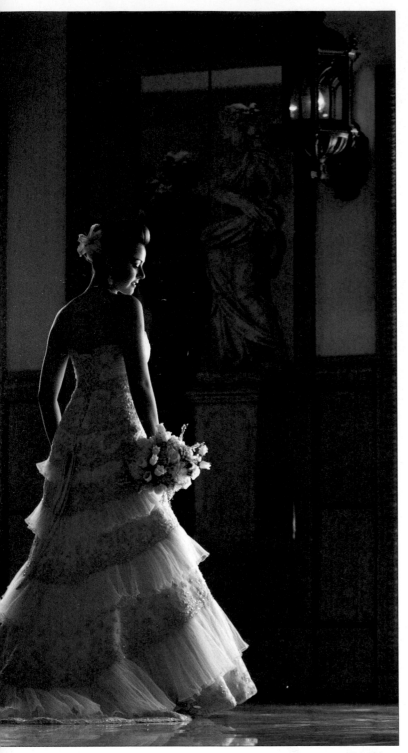

© Ken Sklute

Consider Rim Light

This image was shot with a Canon 1D Mark III with a 70-200mm L 2.8 IS lens. The focal length was set at 200mm to create as narrow a field of view as possible. This ensured that the windows were not visible in the print. The exposure at 200mm was 1/250 sec at f/5.6 at 400ISO.

The lighting was created by two windows: one to the bride's left and one to her right, This created a rim light around her body.

Ken Sklute

www.KenSklute.com

Canon Explorer of Light

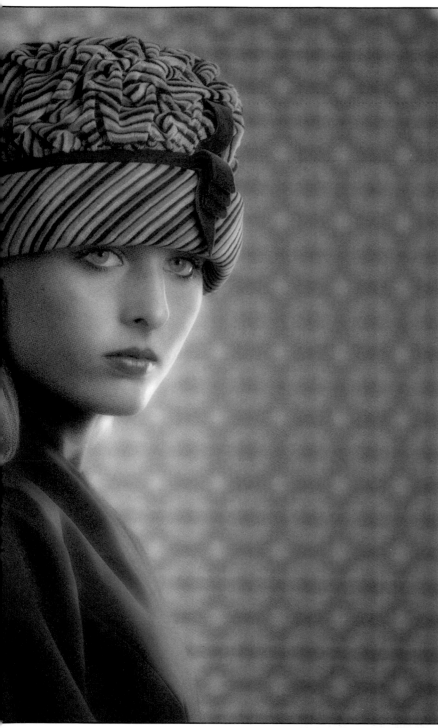

© Judy Host

The Defining Moment

Capturing the defining moment of a scene requires an ability to recognize a lasting image in a scene and the technological know-how to capture it precisely at the right moment.

This portrait, photographed inside a dress shop, exemplifies the beauty of the model's expression and wardrobe. I took the shot during a FotoFusion seminar by Clay Blackmore.

The image was created using a Canon EOS 1D MK III with a 70-200 f/4.0 lens. It reflects some retouching and an Action created by Eddie Tapp called the MZ Soft Focus filter, which enhances and softens the model's skin.

When you create a portrait like this—and you only have an expression to tell the story—learn to see and capture its essence.

Judy Host, Photographer

www.judyhost.com

© Judy Host

Create an Intimate Moment

This image was created using a black background and a single light. Because Andrea's dress was also black, the emphasis is on the face and hands of the mother and the baby. We turned Andrea away from the main light source and waited for the baby to respond to the movement.

When creating this type of portrait, you don't always know what your tiny subject will do. In this case, even though she turned away, the dramatic lighting creates a very intimate moment.

I used a Canon 5D with a 24-105 mm lens. It was processed in Photoshop to bring down the light on the mother's arm just a little bit so that all the attention would go to the mother's expression and the baby.

Judy Host, Photographer
www.judyhost.com

© Ed Pierce

Light Illuminates, Shadow Defines

This is perhaps the most basic tip in this book. Yet it's one of the most important: *Light illuminates, shadow defines.*

Explore the lighting in this portrait. Sure, the highlights are nice, but it's the shadows that give this photograph drama. I call it "Homage to Hollywood."

Here's another tip: Try to create catch light in the subject's eyes. Look carefully and you'll see it in this photograph.

Ed Pierce

www.photovisionvideo.com

© Christian Lalonde

Shape the Light

This photograph was taken for an annual report of a financial institute. The idea was to show growth.

My Liteshaper kit (www.liteshaper.com) was an essential accessory in the creation of this photograph. The Liteshaper is a kit of four square pieces that can be attached with Velcro to a softbox. The kit allows you to modify the opening size on the box or change the shape of it.

My main light was a Lumidyne pack with a softbox, modified with the Liteshaper kit. The kit enabled me to reduce the opening to 8x10 inches, which cut down the amount of light spilling onto the background and foreground.

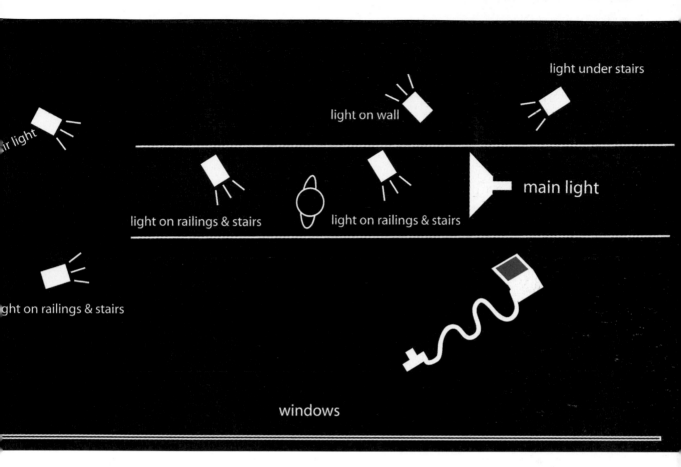

light under stairs

light on wall

ir light

main light

light on railings & stairs

light on railings & stairs

ght on railings & stairs

windows

All my other lights were camera flash units that were triggered with a PocketWizard (www.pocketwizard.com). I shot with my camera tethered to my laptop.

Christian Lalonde • Photolux Commercial Studio • www.photoluxstudio.com/commercial

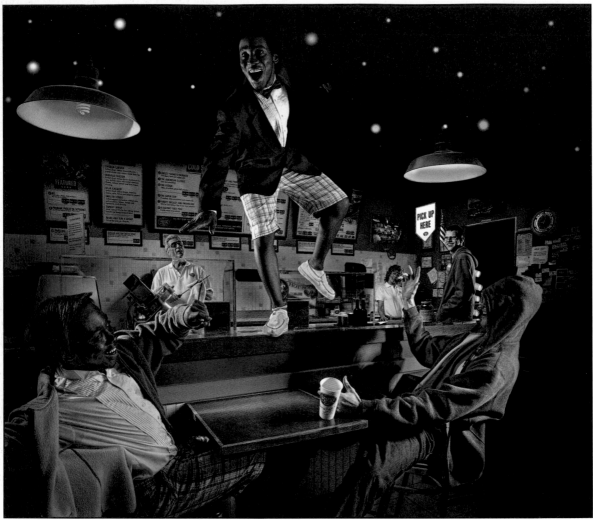

© Perry Harmon

Shoot and Light 'em Separately

Above is a composite image that I created using several different shots.

I set up the camera and put the people in the scene separately—lighting them and shooting them separately. The camera was set on a tripod and remained in the same position throughout the shoot. A few of the behind-the-scenes shots are on the opposite page.

I did a little tweaking here and there, then "replaced" the ceiling with a black-to-dark-blue gradient, darkening somewhat randomly. Next, I added the stars.

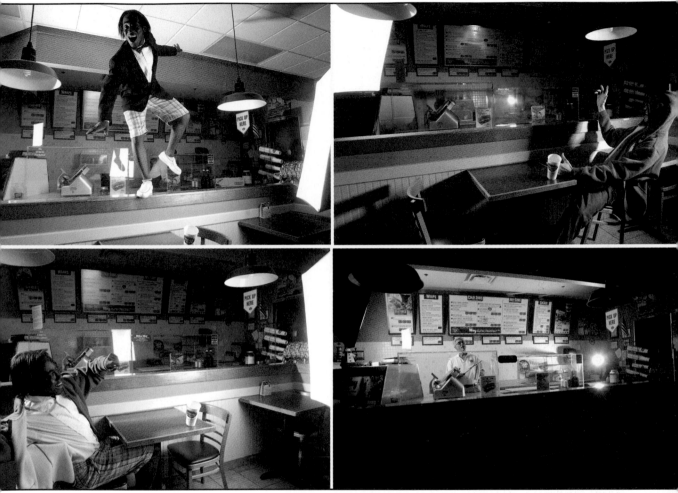

© Perry Harmon

I merged the layers and saved my file as a completed .psd. Then I duped the "finished" layer and used the LucisArt Whyeth effect in LucisArt (www.lucisart.com) on the duped layer. Finally, I lowered the opacity of the Lucis layer and masked various areas.

My advice: Experiment with composites. Lots of work to light, but also lots of fun.

Perry Harmon • www.perryharmonphoto.com

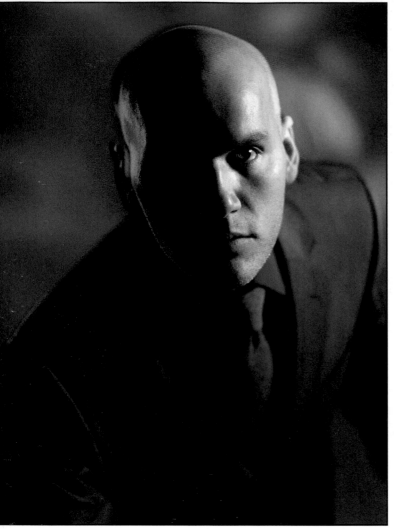

© Paul Teeling

Inspired by the '60s

For this image, I was inspired by TV series from the sixties, like *The Avengers, The Saint,* and *Matt Helm* (Dean Martin).

I wanted to create a sense of drama and movement.

The background is a grey seamless. Using a 5k movie light with a Fresnel lens allowed me to create an interesting pattern with a cucoloris (aka cookie). I covered the cookie with a patchwork of colored gels to give it a psychedelic look.

I lit my subject with a split light using a Profoto compact 300 strobe with a parabolic reflector. I also had a reflector putting light into the shadow side of his face, but I kept the shadow down three stops from the main light.

The kicker light is another Profoto 300 with a red gel.

I shot the image with a Mamiya 645 Pro TL using the LEAF Digital system tethered. I used a 55 mm lens at 50 ISO. The aperture was fairly wide open—I'd guess f5.6. I wanted a nice fall off in the focus.

I dragged the shutter to get a sense of movement. The modeling light on the main light was turned off to freeze the action with no blur. However, I left the modeling light on the red kicker light on.

Originally, I tried it at full power with that modeling light off, but even at full power the exposure as a bit dull. Adding the modeling light brought up the exposure and gave the shot a nicer sense of dimension.

I had the model lunge at the camera, landing on a mark on the floor to help ensure a good focus.

Paul Teeling

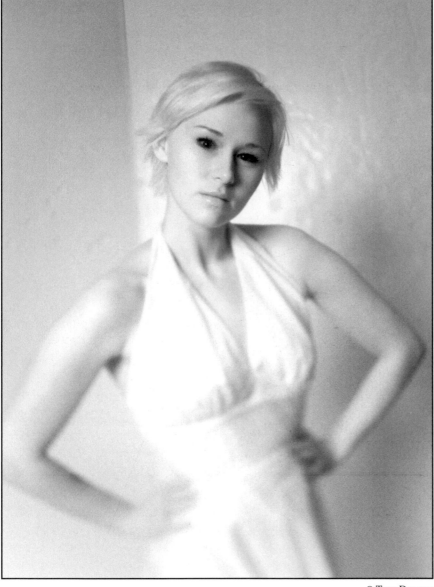

© Tony Downer

Do-it-Yourself Tilt/ Shift

This shot was created with all light tones on a white background. The model is close to the background and the scene is lit flatly with a soft, even light.

I used one simple light reflected off a white umbrella. I experimented with partially removing the camera lens during the shoot to blur parts of the image.

This is a kind of "do it your self" tilt/ shift lens.

Tony Downer

© Larry Hersberger

Bring Back the Magic of Portraiture

I believe that serious portrait photographers should separate themselves from the amateur in every way possible. And the visual power of a professional studio set helps achieve this goal. Not only does a well-planned set take away your customer's breath, it also brings three-dimensional art, sculpting and architecture to your image—indoors and outdoors.

What's more, because the subjects are actually part of the sets, they feel more important than if, for example, they're just sitting on a stool in front of a flat background. They know that something special is happening.

I created all of these images in a space less than ten feet in length; yet in the image, the location looks huge.

My secret: I used Back to Back Design Works (www.b2bdw.com) studio sets. These sets, which I design, can be set up anywhere, indoors and out, in just a few minutes.

Help bring back "the magic" to your studio, your images and, most important … your customer!

Larry Hersberger • www.b2bdw.com

© Larry Hersberger

© Beverly Anderson Sanchez

Blessed Soft Lighting

This image of a Theyyam deity was taken at Bhagavathi Temple in Kasargode, India, in March 2009. It was an overcast day, so the cloud cover diffused the sunlight and produced soft and flattering lighting—the kind of lighting that softboxes and umbrellas can produce in the studio.

If you're going to shoot people pictures outdoors, an overcast sky is a blessing; *pray for it ...* as Rick Sammon says in his workshops.

The dark vignette was created using the Burn tool in Adobe Photoshop CS4. I've included a behind-the-scenes shot to show you the sky as well as the preparation that went into making this photograph. In the field and in the studio, props, makeup and assistants help—big time.

Beverly Anderson Sanchez • *www.photographybybeverly.com*

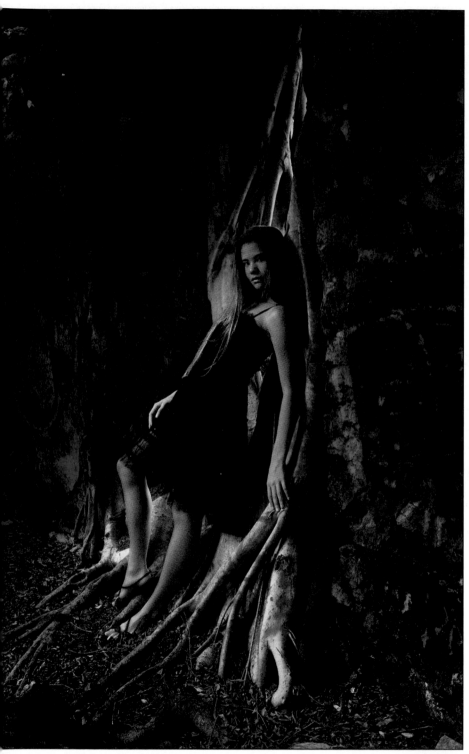

© Eddie Tapp

It's All About the Light

This image, photographed in Hawaii, is completely natural … taken with available light with no modifiers.

We were deep into what I call a *pocket of light*, created by an overhanging ceiling with an opening to the right of the model. There was also an opening behind the model to the right that allowed the beautiful *taste light* on her leg.

The image was created using the Canon EOS 5D MKII at 1/6 second and f/5.6. Photoshop was used to generate the black-and-white background.

Eddie Tapp

www.eddietapp.com

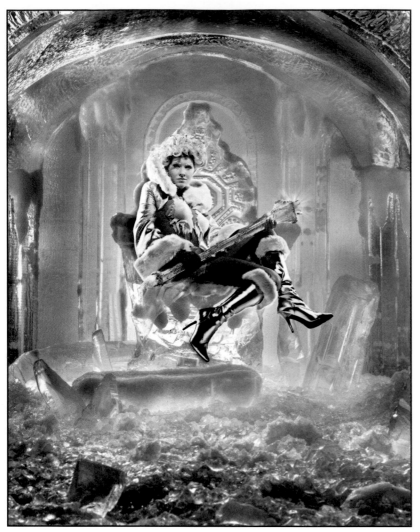

© Eric Eggly

Go to Extremes

Sometimes you need to go to extremes to make a great photograph. Think Big!

For this photograph, the model and the "throne room" were shot independently. The model was photographed in a studio, and the throne room, which was carved by two award-winning ice sculptors, was shot outside at twilight. The temperature was 18 degrees F.

I used eleven FJWestcott TD5 Fluorescent lights—some with blue gels—to create the dramatic lighting. For the model shot, I used five lights. The main light was a Westcott Masters Brush; two large strip lights were used as side lights; and two strobes with wide-angle reflectors lit the background.

Eric Eggly • www.ericegglyphotography.com

© Perry Harmon

Plan the Shoot, Process the Shot—Carefully

This was shot in a local deli franchise.

I used two softboxes to light the scene. One was positioned at camera left, facing the happy sub man, and I deliberately allowed the light from this softbox to spill onto the back wall a bit. The wall was white tile, and by allowing the spill, an ever-so-subtle fill light bounced from yet another angle without the need for another light.

Notice the slightly brighter area on his right … on his forehead. No, you're looking in the wrong place. I said HIS right, not YOUR right!

The second softbox was a little higher and to camera right, facing the man (and functioning as a fill light). It was turned a little to the right to spill onto the background.

The final light in this setup was a Speedlite on a short tripod hidden behind the subject and aimed at his head. This not only created the rim light you see on the left side of his face, but it also added more reflective fill light off of the white tile wall.

All three lights were triggered with wireless remotes. The post-processing was a succession of layers using Photoshop's Surface Blur tool and the Lucis Art filter. The post-shoot activity included a succession of layers of roast beef, cheese, tomatoes, onions, jalapeno peppers, various secret seasonings and some good old Southern sweet tea, all courtesy of Ralph at Jersey Mike's. Mmmm … good stuff.

Perry Harmon • www.perryharmonphoto.com

© Perry Harmon

Use What You've Got

This was an impromptu shot taken after my daughter's birthday dinner at a local restaurant. Two lights were used, and their precise positioning was critical.

Fortunately the city knew this somehow and hired an expert to put the streetlight and the light over the window in exactly the right places. How these public servants knew that one day I'd show up to take a picture on that very bench is uncanny. Indeed, the lighting comes from a streetlight at camera right and an overhead light in front of the restaurant.

It's also amazing this shot came out as well as it did … considering it was shot at one second, handheld. Post-processing included color correction for two different light temperatures (incandescent and mercury vapor) using different layers for each. Judicious use of Photoshop's Shadow/ Highlight helped to lighten the shadows a bit, and Hue/ Saturation added a little extra color "punch." Finally, a dose of LucisArt finished off the look.

Did someone mention Norman Rockwell?

Perry Harmon • *www.perryharmonphoto.com*

© Judy Host

Bounced Light is Nice

This image of Gina was created using a bounced light effect coming from several different walls.

She was photographed during the middle of the day and placed against a wall where the lighting was the best. There is a little bit of deckled light on her chest that adds just a touch of drama to the image.

The photograph was created with a Canon 5D Mark II using a 70-200mm lens at f/4.5 and 1/80 second at ISO 100. It was processed in Photoshop CS4.

Judy Host

www.judyhost.com

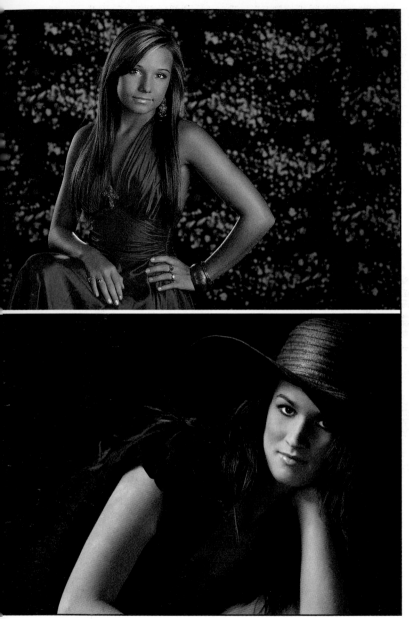

© Liddie Deshotel

Shoot Beautifully Inside the Studio ... and Out

In the top photo Bria was shot in my studio with a Canon 5D and a 70-200mm F/2.8 IS zoomed to 90mm. The scene was lit with Ultra 1200 White Lightning strobes.

For the main light, I used a Chimera 3x4 softbox set at F/4.0 and an accent light with a Westcott 12x50 strip placed diagonal to the main light, set at F/2.8. A 4x6 reflector was used as a fill light.

I love the how the Westcott 12x50 strip light illuminates her right arm, hair and cheek ... and even falls on her left arm all at once!

In the bottom photo Cassidee was shot on location at an old Cotton Mill with a Canon 5D Mark II and a 70-200mm F/2.8 IS zoomed to 145mm.

Light from an open doorway to the right of the subject was used as the main light. Cassidee was placed about four feet from the open doorway with a reflector placed to her left. Settings were: ISO 640 at 1/50 second at F/3.5. I just love the simplicity of natural light!

My advice to aspiring pros: Learn how to shoot in the studio *and* in the field.

Liddie Deshotel

www.portraitsbyliddie.com

© Lou Jones

Traveling at Lightspeed

We mulled over the cover for my book, *Speedlights & Speedlites: Creative Flash Photography at the Speed of Light* for quite a while … and rejected a lot of ideas. Then, by accident I struck upon the idea to feature the Speedlight in the photograph.

I wanted to imply movement. We handled this in a couple of ways: The photograph was shot on a slant so the woman's hair hung at an angle. And we used a fan to add to the illusion. A tungsten light was placed behind the model to create some blur.

Four Speedlights in three groups doing separate jobs were used. They light her face and hair with daylight and add the comet-like background light, emphasizing the blue color but keeping it off her face. The trick was timing. It was important to know when to have Leah initiate the stroboscopic Speedlight in her hand for each exposure.

We used lots of gobos to keep each light from "contaminating" the others, so there was a great deal of fine tuning. But the whole shot was done in about twenty exposures, which is a testament to the methods we have at our fingertips today.

Lou Jones • www.fotojones.com

© Dean Zulich

Use Sunlight as the Key Light

This image of the recording artist Joss Stone is one of my all-time favorites; it was captured at Agua Dulce Airport, outside Los Angeles. It was part of Vh1's The Shot, a reality show I participated in … and finished as runner up.

I used a Canon EOS 1Ds Mark II, EF 85mm 1.2 L lens. For lighting I used sunlight as the key and a large 5000W HMI as a backlight (F/1.4 1/8000 sec and ISO at L50).

The challenge of this photograph was quite intense, as we had ten minutes to set up and five minutes to shoot.

We did have more than one HMI available, but I realized that even though still high, the sun was at a decent position to provide key light. One thing about the air in California: There is always a diffusion layer, so it is possible to shoot in direct sunlight.

I used the aforementioned HMI as a backlight, and it worked perfectly. It gave a cinematic feeling to the image, as I envisioned. I had a story in my mind of the diva left alone at the airport … or perhaps waiting for her flight. I leave that part up to the viewer.

The image was published in *Marie Claire*, January 2008.

Dean Zulich Photography • *www.deanzulich.com* • *www.datacolor.com* • *www.imagenomic.com*

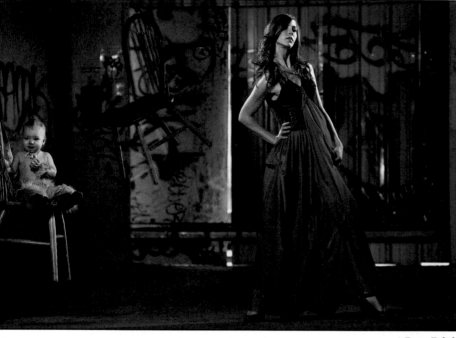

© Dean Zulich

Many Lights + Large Crew = Cool Image

This image was part of a self-assigned creative project that I submitted to multiple photo contests. I was fortunate to collaborate on the project with the very talented local designer Logan Neitzel, who created fashions for the campaign.

One of the photos from the series ended up being the flagship image for Imagenomic's ad campaign. This image required an elaborate lighting setup. I used a total of nine lights and had a large crew of five assistants on the set. That's in addition to hair, makeup and styling personnel.

I shot with an EOS 5D Mark II, set at EF F/2.8 70-200 IS L, 1/80 sec, F5, ISO 400. I used a ProFoto Acute 2400 lighting kit with three heads and six Alien Bees lights.

To light the entire background of this abandoned sawmill, I used two lights for overall illumination. I had two rim lights on the female model in addition to the key light and hair light. The baby was lit from both front and the back. The last light head was used for the levitating chair that we suspended from the pipes on the ceiling.

My overall idea was to create a surreal feeling and enhance a typical fashion shot with props and extras. Extremely cold weather didn't help the issue, but the deadline for one of the contests was imminent and left us with no choice.

Overall, it seemed that it was worth the effort; you be the judge.

Dean Zulich Photography • www.deanzulich.com • www.datacolor.com • www.imagenomic.com

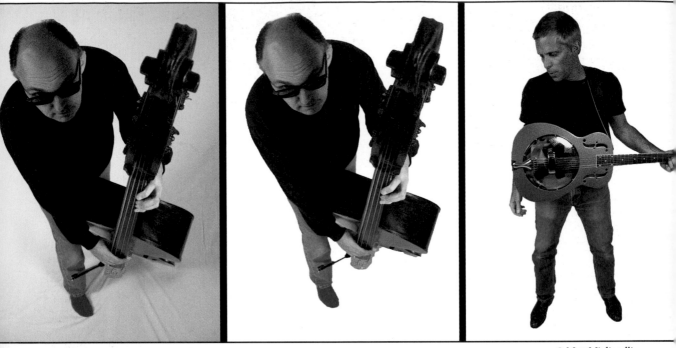

© Matt Migliorelli

Who Needs Expensive Gear?

Top secret, insider information here, everyone! You don't need all the expensive studio gear to create professional looking photos.

Yep, thanks to a couple standard household lights and open windows, I was able to get great lighting on these subjects—my dad (right) and Mark Minkler, a member of his band: the Real Rough Diamonds.

The background is a large cloth backdrop that I purchased from Adorama for just a few bucks. To remove the background, I used Photoshop's Magic Wand tool.

There are other ways to go about this, but I am not a Photoshop wizard. See more of these pictures on The Real Rough Diamonds website: www.realroughdiamonds.com.

Matt Migliorelli • www.flickr.com/photos/matthewmiggz

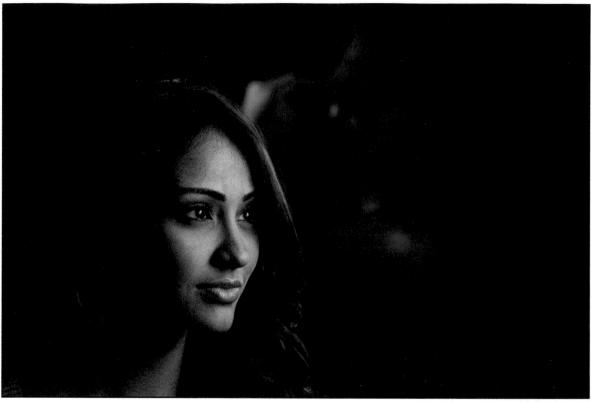

© Jerry Ward

If You Don't Have All Day …

At a recent photo trade show, I had the opportunity to shoot at the Canon booth. When it was my turn, I knew that time was short. So rather than going into a big lighting ordeal, I decided quickly to use one of the models as an out-of focus-background asset in the photo.

This brings your eye and focal point back to the model in the foreground, but it also gives interest to the photo overall. You wonder what the relationship is between this attractive couple.

By putting a light-blue filter over the rear light that falls on the back model … and turning it down one stop … I created tension—a specific mood that I was going for.

The front main light was a small 2 x 3 ft softbox, set at about 90 degrees to the camera. On the rear light was a blue gel and barn doors, up high and to the left. The lights came from opposite sides of the subjects. Some of the back blue light was purposely allowed to shine onto the front model's hair. There is a reflector to the right bouncing light back onto the background model's shoulder.

Jerry Ward • Professional Market Specialist, Canon USA • www.usa.canon.com

© Joseph Victor Stefanchik

Teaming a Photographer and Stylist

I recently had the pleasure of photographing an "Easter baby" … just 14 days after her birth.

This image is a collaboration with my business partner and wife, Anne Farrar. While I fire the camera, Anne plays a huge role in the production and styling of every portrait I photograph.

I've been shooting with Canon Speedlites since the inception of EOS, and for this image I chose to illuminate the entire scene with two Canon 580EX II Speedlites.

We assembled a series of Matthews C Stands and various other supports to ensure the safety of our subject. The newborn was safely secured along with two additional backup supports in place.

This image was captured on an EOS 5D Mark II, Canon 70-200 f/2.8 IS lens and two Canon 580EX II Speedlites. The final exposure was 1/100 at f/3.5 and ISO 200. The camera was supported on a Gitzo tripod and a Really Right Stuff BH-55 ball head.

The RAW file was converted with Canon's Digital Photo Professional software and enhanced in Photoshop CS4 with actions from the Totally Rad Mega Mix (http://www.gettotallyrad.com). The image was completed with "Dune," a texture from the Fine Art Textures set (http://enlighten.jeshderox. com/#textures).

Joseph Victor Stefanchik • www.jvspictures.com

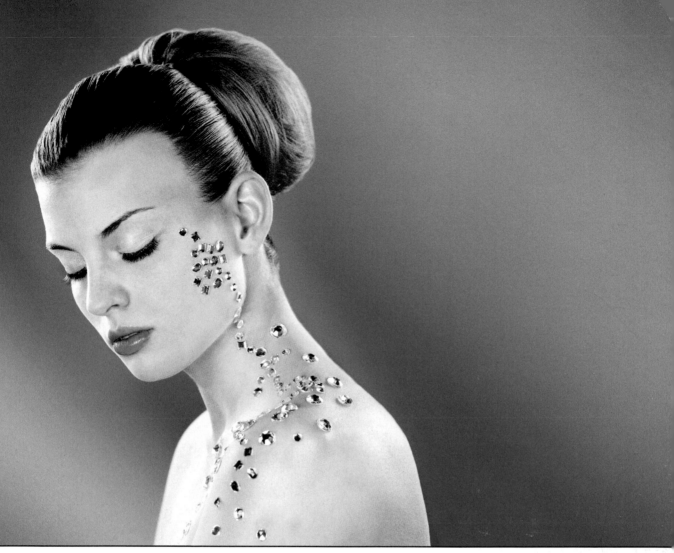

© Chayanne Marfisi

Part XI

Student Studio Lighting Experiments

Over the years, I've had the honor of giving seminars at the Hallmark Institute of Photography (www.hallmark.edu) in Turner Falls, Massachusetts. The highlight for me is seeing the work of the students. Throughout this chapter, you'll get a glimpse of the creative artistry of just a few of the students in the class of 2009.

© Shannon Bradley

Shannon Bradley

To light this model, I used two softboxes and positioned them about a foot away from the subject—one on each side. I did this to create highlights that outline his arms and define his muscles.

The model stood very close to the softboxes. This created a short fall off of light that infused shadow on his body. To feather the light, I turned the face of the softboxes toward the camera slightly.

To fill in some detail on the model's face and to add catch light to his eyes, I added a beauty dish in front of the model. I love the symmetry in this image and was careful in placing lights to achieve it.

My vision for this photograph was to create a sense of power for the model and generate intensity in his eyes to connect him with the viewer.

© Amy Dieker

Amy Dieker

I love to photograph movement.

When making this shot, I wanted to capture the vibrancy and strength of movement in dance, so I made it a point to shoot on a solid white background. This brought the focus to the dancer and emphasized her shape and form.

I love this gesture because it captures the vitality and grace of movement.

To freeze the motion of my dancer and capture my vision, I used Profoto compact heads.

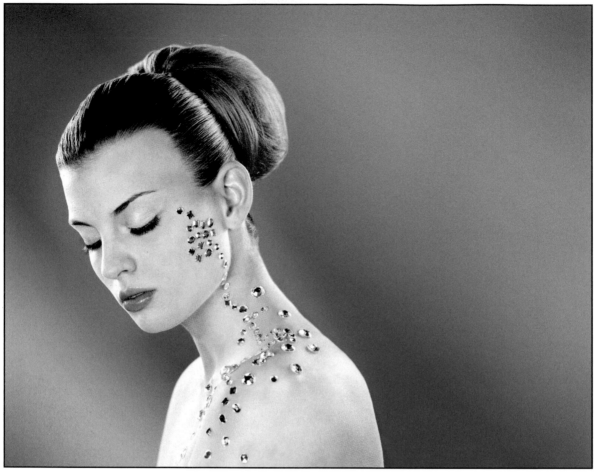

© Chayanne Marfisi

Chayanne Marfisi

I wanted this photograph to have a glamorous, colorful look with a soft, beautiful, glowing mood.

To achieve this effect, I used four softboxes around the model to make her skin and hair glow, and I positioned one specifically to make the jewels and makeup shine. I used a grey background and lit it with a parabolic reflector with a blue gel. The light was positioned low and created a feathered streak of blue across the background.

I moved the model away from the background and shot at a relatively wide f-stop (f /6.7) to knock the background a bit out of focus. This meant I didn't have to worry about little dings or dents in the paper, and the blurring effect helped spread the light out a little.

Adding a slight vignette and bumping up the saturation in the background in post-production further enhanced the glow of this image.

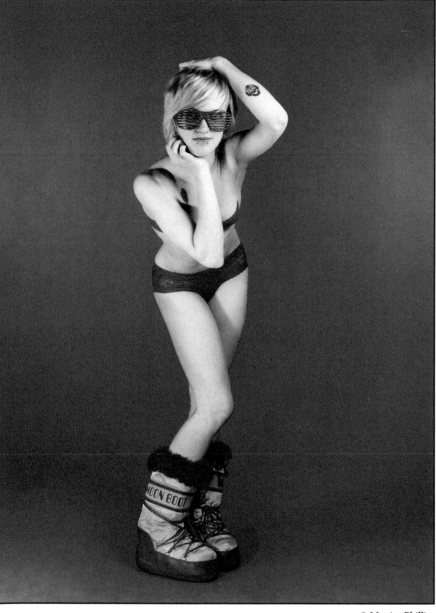

© Monica Phillips

Monica Phillips

I was trying to make the photo as bright as possible without over-lighting to give it a poppy 70s look. I used two large softboxes at 45-degree angles to create a wide, flat light on the model.

To add some highlights and a bit of direction to the light, I used a 1 x 4-foot softbox positioned low to the ground. This illuminated the Mood Boots and the model's legs.

The background was yellow to begin with, and since the model was cross-lit evenly, soft shadows on both sides created interesting patterns in deeper yellow. The variation in color created depth to the image and kept it from having a flat, cutout look.

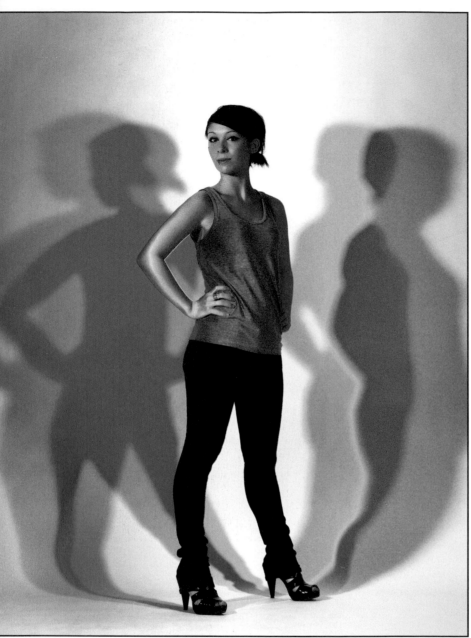

© Chris Pino

Chris Pino

I got the original idea for this photograph from a Hallmark alumnus, Derek Wood. He shot a whole series of images with this type of lighting.

I decided to try it for myself and love the outcome! I lit this model with four strobes with parabolic reflectors and gels. It is especially interesting to me to see how light behaves. Given the principles of opposite colors, the red gel actually casts a cyan shadow; the cyan gel casts the red shadow; and so on. So when all the gels meet on the model, they create a neutral, white light … so her face does not have any particular colorcast. It's clean and natural.

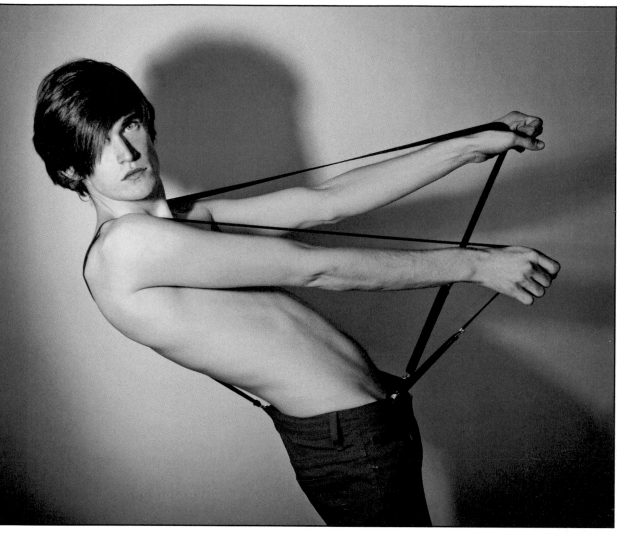

© Jacquie Puoci

Jacquie Puoci

For this shot, I envisioned a model wearing red jeans with no shirt. And I knew I wanted a young, hip, urban fashion-y type of look. But other than that, I wasn't sure what I wanted for this image.

To see what could emerge, I brought a variety of props (scarves, suspenders, etc.) and experimented with different props and poses. We had a great time coming up with this shot.

I used a silver umbrella for a strong, poppy light; it created the soft-looking spotlight effect. I filled the shadows with a 1 x 4-foot softbox. My model was close to the background, and this created an interesting shadow. I used a white background and added some color in post production.

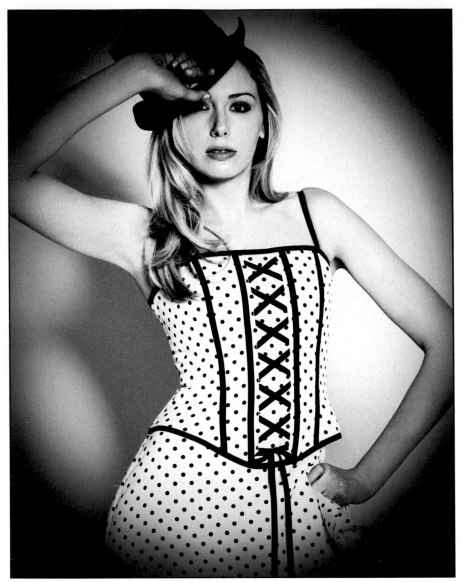

© Amy Roberts

Amy Roberts

To create a fashion-oriented photograph, I used a beauty dish from above to light the model's face with soft, even light. I filled the shadows on her face and clothes with a strong fill light. This ensured she was lit evenly, and it generated a strong contrast of a shadow on the white background. My model was close to the background, which emphasized the spotlight effect.

Because the lighting was so contrast-y, I desaturated the image a little in post production and strengthened the vignette to add some drama. I ended up with a stage feel that I love.

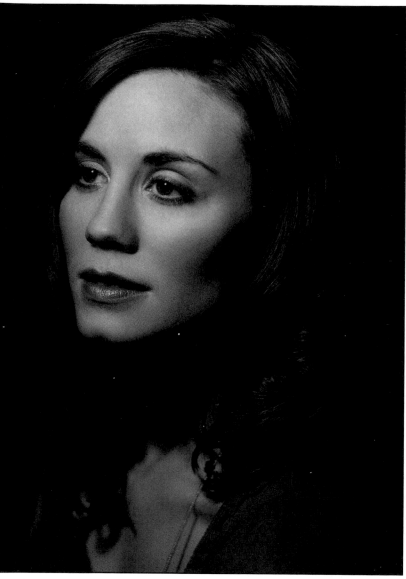

© Lisa Wood

Lisa Wood

The inspiration for this image came from old Hollywood glam. I wanted the high-contrast effect coupled with a look of glowing skin.

To achieve the smooth skin, I used a surface blur with Photoshop and masked it in.

Since I was going for a soft, almost-painted look, I used a single Smith Victor hot light and a long shutter speed of 1/15 second. The light was close to the subject—about a foot and a half away—and aimed downward.

The model was about 12 feet from the background; and since I did not use additional lighting, the background is very dark. I hung black curtains in the background for a dark stage touch, and I added drama by using very contrast-y lighting.

Finally, it was important to find a pose that captured all this work in setup. I think it's quite reminiscent of classic movie star style.

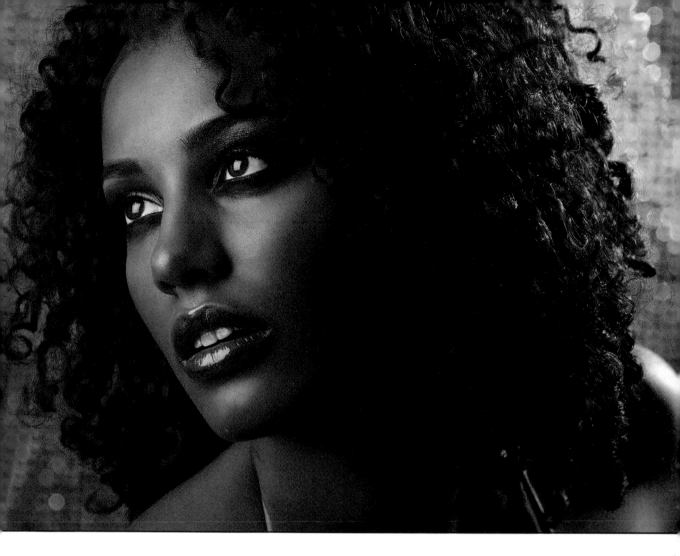

Part XII

Photoshop Enhancements

Vered works hard to create the very best in-camera images. You've seen them throughout this book. In this chapter, she gave me the okay (after almost killing me with stink eye) to apply some of my favorite Photoshop techniques to her exquisite photographs. Thanks Vered!

Count on Changes

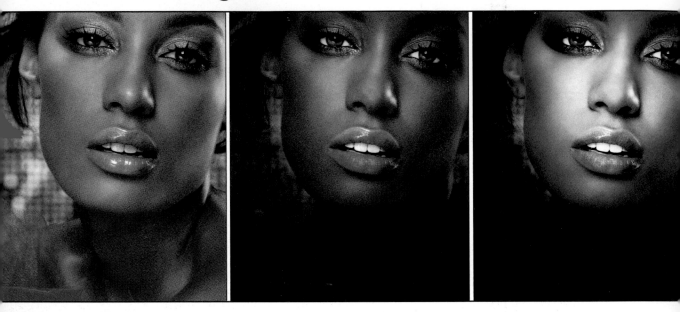

As a studio photographer, change is the name of the game. There are three reasons for this:

One, your clients will have their own opinions on best shot. These opinions will basically depend on the composition and lighting of the photograph and how the model looks. Clients will often suggest changes during the photo session, so don't get rattled if this happens.

Two, clients usually have ideas about what they want in terms of post-processing digital enhancements.

Three, you'll probably have a whole slew of creative ideas on how to tweak your images in Photoshop. We'll address the digital enhancement side of change here.

The Secret: Know the capabilities of Photoshop and how to best use them.

Test yourself: Compare the left and middle images above and count the number of changes. Then come back here to check yourself. No peeking!

Okay, here are the eight enhancements that were made to this photograph. Did you see all of them?

1) I used the Dodge tool to whiten the model's teeth and the whites of her eyes.

2) I used the Color Replacement tool to change the color of the model's eyes from brown to green and also to change the color of her lips to better match the material in the lower left corner of the frame.

3) The Healing Brush minimized the reflection on the model's lower lip.

4) I used the Clone Stamp tool to reduce the number of white spots in the background.

5) I then created an Adjustment layer to increase the overall saturation of the image.

6) Another Adjustment layer increased the contrast of the image.

7) I applied a Flashlight filter (Filter > Render Lighting Effects) to mold the lighting around the model's face.

8) I used the Clone Stamp tool to minimize the reflection on the tip of the model's nose.

When shooting and editing photographs, try to envision how a photograph will look in black and white, as illustrated in the example on the right. This variation is just one of countless possibilities.

Add a Spotlight or Omni Light

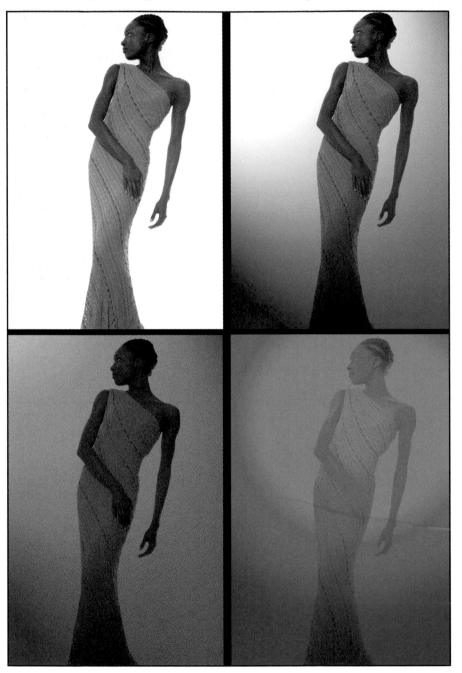

Here's a quick and easy method for adding a spotlight effect to an image. Doing so can change the mood, feeling, drama and color of a photograph.

The Secret: Use Photoshop's Render Lighting Effects (Filter > Render > Lighting Effects).

The Lighting Effects filter offers several different types of Light Types, including Spotlight and Omni Light.

With each of these Light Types, you can change the color of the light by clicking on the Color Box (at the right end of the Intensity slider) in the Lighting Effects dialog box. You can also change the size of the applied lighting effect by clicking on any of the anchor points in the Preview window; swivel them around and pull them in and out.

The images on the opposite page illustrate the following settings (clockwise, from top left): original photograph, Spotlight with gray selected, Spotlight with orange selected, and Omni with blue selected.

Sure, experiment with the Intensity and Properties, but Spotlight and Omni light are great options for adding creative lighting effects to your images.

Change the Lens and F-Stop

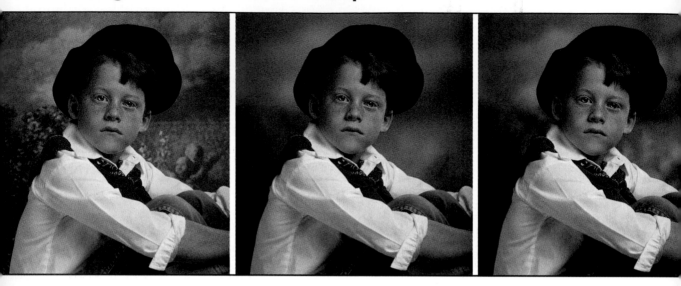

Pros use fast lenses for portraits—such as 50mm, 85mm and 105mm set at f/1.2 and f/1.8—because they offer extremely shallow depth-of-field when set at their widest aperture. These lenses and settings are also popular among pros when they're shooting a subject at close distances. It generates super-sharp images.

Creating the fast-aperture effect in Photoshop is easy.

The Secret: Use Alien Skin Software's Bokeh plug-in, which is available for download at www.alienskin.com. Get a 15% discount when you use this code upon checkout: ricksammon.

Step 1) In Photoshop, make a selection of your subject using the Quick Selection Tool on the Tool Bar.

Step 2) Once you have made your selection, invert it (Select > Inverse Selection). Now the area around your subject is also selected.

Step 3) Open the Bokeh plug-in and choose the desired lens effect.

In the Bokeh Preview Split window, you can see the before and after versions of your lens and aperture choices.

Here is the result of using a Canon EF 50mm f/1/.8 lens effect set at f/2.5 (center image on the opposite page).

In the image on the right on the previous page, you can see the effect of using the factor setting of Triangle Treat.

Create Beautiful Black-and-White Prints

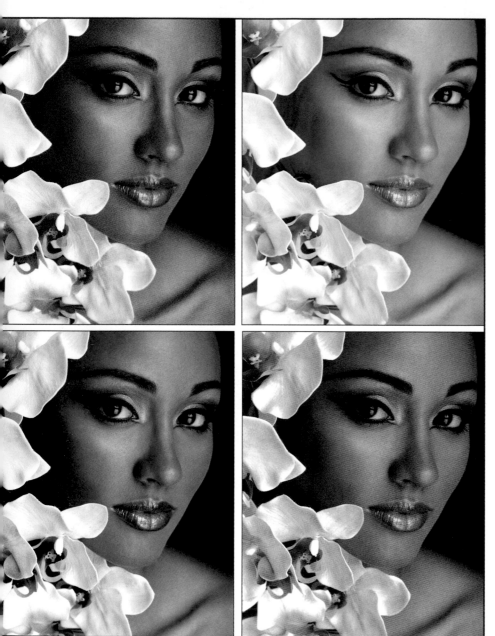

With one of today's high-quality inkjet printers loaded with special black-and-white inks, it's easy to create beautiful black-and-white prints in Photoshop. These prints provide endless tones and contrast possibilities, just the like the prints that pros made years ago in their wet darkrooms.

The Secret: Use a black-and-white adjustment layer.

When you create a black-and-white adjustment layer (Layer > New Layer > Black and White), you get the Black and White dialog box. There, you have a tremendous amount of creative control over your image. Here are just a few examples—applied to the out-of-the-camera image.

At the default setting, Red is at 40%. The result is the image on the top right.

To darken the image … and add a bit of contrast, the Reds triangle slider is moved to the –3% setting. The result is the image on the bottom left.

Want another creative option? Click on the Tint box.

When you click on the Tint box, the Color Picker window opens. Click on any color to add your own tint to your image. The photograph on the bottom right shows the result of applying the default tint.

Beyond Black-and-White

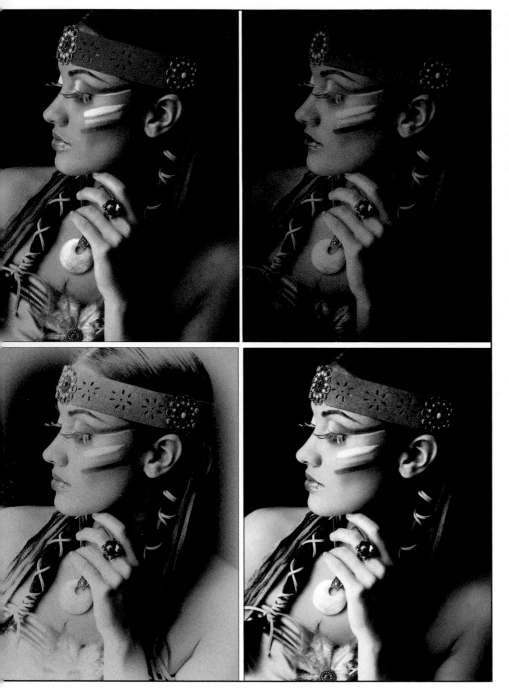

On the previous spread, we took a quick look at creating black-and-white images in Photoshop. That's cool, but there is a quick and easy way to go beyond traditional black-and-white images.

The Secret: Use Nik Software's Silver Efex Pro plug-in, available for download from www.niksoftware.com. Get a 15% discount when you use this code upon checkout: ricksammon.

When you open Silver Efex Pro, you get a dialog box that offers many creative options. Styles are on the left, and fine-tuning controls are on the right.

Pick a style first and then customize your image. Try as many different combinations as possible. With all the settings, you have literally limitless controls.

The illustration on the opposite page shows (left to right, from top): Vered's straight shot, Ambrotype at the default setting, Antique Plate and Darken Contrast Vignette at the default setting ... with an extra touch. Read on.

As you can see in the bottom right photo, there is a hint of color in the image. That's because after applying the effect, which is placed on a different layer, the Opacity of that layer was faded by 20%, allowing a hint of color to return to the image.

When applying these effects, experiment with fading the Opacity of the new layer for even more creative options.

Create a High-Fashion Stylized Look

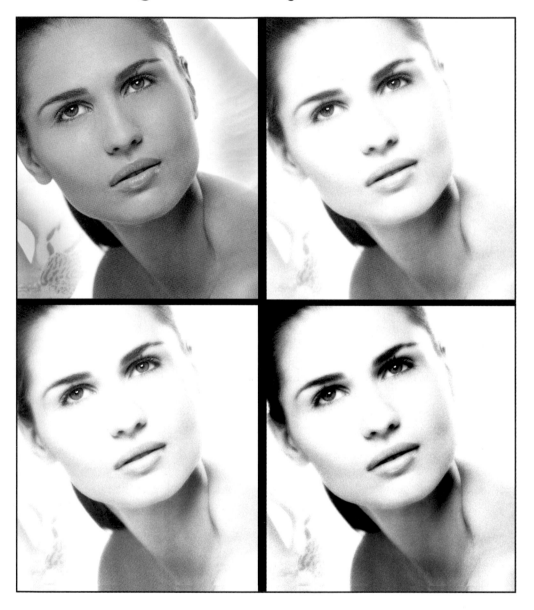

Check out fashion and glamour magazines, and you're sure to see images of models that seem to glow—ethereal images that convey a sense of softness, as if the subject is in some sort of dreamland.

The Secret: Use the Diffuse Glow filter (Filter > Diffuse Glow).

The Diffuse Glow dialog box is where the magic happens. It's where you can control the Graininess, Glow Amount and Clear Amount of your images. Play with these sliders to create your own one-of-a-kind images. But don't stop there; more creative effects await you.

In our illustration on the opposite page are (left to right, from top): the original image, Diffuse Glow effect applied at the default setting, Diffuse Glow effect applied after the image was converted to a grayscale image, and Diffuse Glow effect applied to the grayscale image with a bit of a boost in contrast.

The idea when using all filters and plug-ins is to keep on truckin' so to speak. Experiment with the adjustments and tools to see how you can create creative and fanciful images.

Frame It

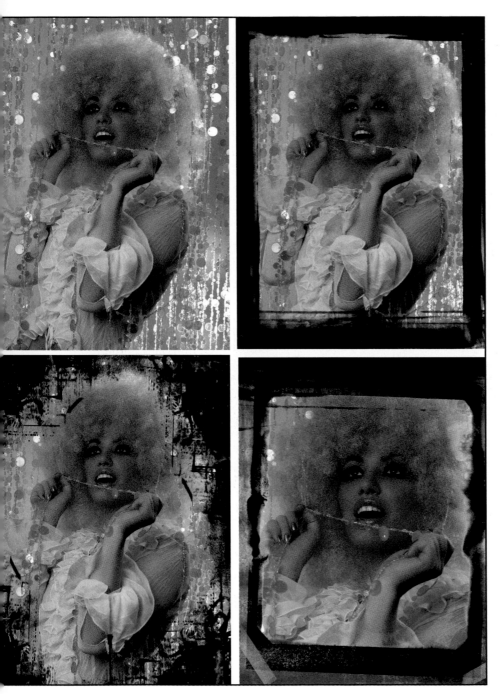

Quick question: How do you think you can make your images stand out in a book or magazine or on a web site? That's right! Frame 'em.

Digital frames, just like traditional frames holding pictures on a wall, help to draw attention to the subject, which artists have done since the Renaissance.

The Secret: Use onOne Software's PhotoFrame 4.0 Professional plug-in, available for download from www. ononesoftware.com. Get a 15% discount when you use this code upon checkout: ricksammon.

The screen grab on this page offers a glimpse of the unlimited frame possibilities that await you in PhotoFrame.

The first step is to select a type of frame from the Frame Library. What's cool about this frame plug-in is that you can see in the Preview window exactly how the frame will look when it's applied to your image.

The next step is to customize your frame by adjusting the Glow, Shadow, Edge, Bevel Background, Options and Border.

I have my PhotoFrame window set up so that I can see all the aforementioned controls individually. Your window will not look like this unless you click and drag the tabs to their own separate space in the window.

On the opposite page are (left to right, from top): the original image, one of the Camera Frames, one of the Grunge Frames and one of the Senior Frames.

My best advice here: Play!

Add a Nice Vignette

The photograph on the left is nice enough; but when a vignette is added, the picture looks more artistic. Notice that the vignette in the middle has a hard edge, while the image on the right has a much softer edge.

The Secret: Use the Vignette (selection) Action and choose a high Feather Radius to soften the edges.

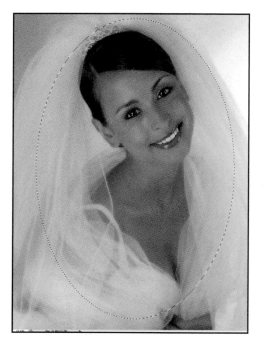

It's easy to create the soft-edge effect. Just follow these steps.

Step 1) Use the Elliptical tool on the Tool Bar and make a selection around the subject.

Step 2) Go to Actions (View > Actions) and click on Vignette (selection), which is the top-most action.

Now here's the secret: If you select a low Feather Radius (5 is shown here), you'll get a hard-edge vignette, as shown in the center picture on the opposite page. Therefore, you want to select a high Feather Radius. I used a Feather Radius of 100 on an image with a resolution of 300PPI to create the soft-edge vignette you see on the right.

Create Professional Color Effects

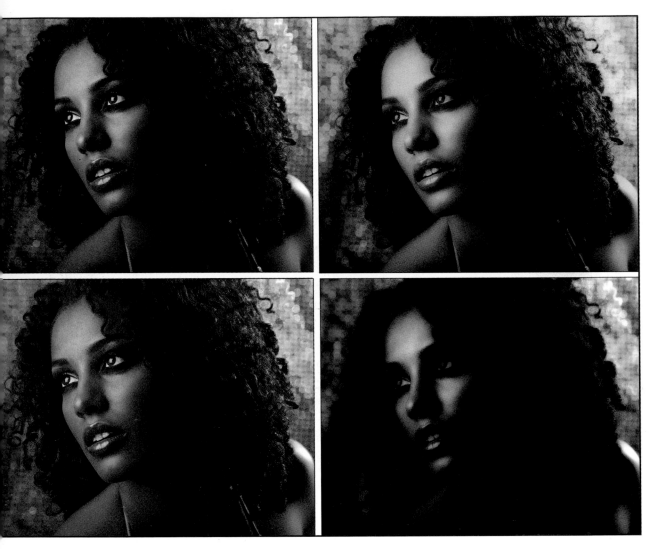

Professional studio photography is all about creating a certain look, mood and feeling. Sure, straight shots are nice. But by adding a few creative effects, your images can go to a whole new level—and become versatile.

In the early days of digital imaging, it took lots of Photoshop know-how to create special-effect images. Today, it is much easier.

The Secret: Use Nik Software's ColorEfex Pro3.0 plug-in, which is available for download from www.niksoftware.com. Get a 15% discount when you use this code upon checkout: ricksammon.

In the ColorEfex Pro window, dozens of creative effects are listed on the left. Once you select an effect, you can access tons of creative options by using the tools on the right. Different tools are available for different effects; the variety allows you to fine-tune your images to your own personal taste.

I like to view before-and-after versions in the window, but you can choose to view only the end-result. There's also a loupe feature that lets you zoom in on your image to see the effect on a certain area.

On the opposite page are (left to right, from top): Vered's original image, Duplex effect, Reflector effect and Midnight effect.

It's easy to get carried away with this plug-in … simply because the effects are so cool and so much fun. However, just like all photographic techniques, too much of a good thing is not a good thing. In other words, don't overdo it. Don't forget the beauty of a straight shot.

Add Simple Artistic Effects

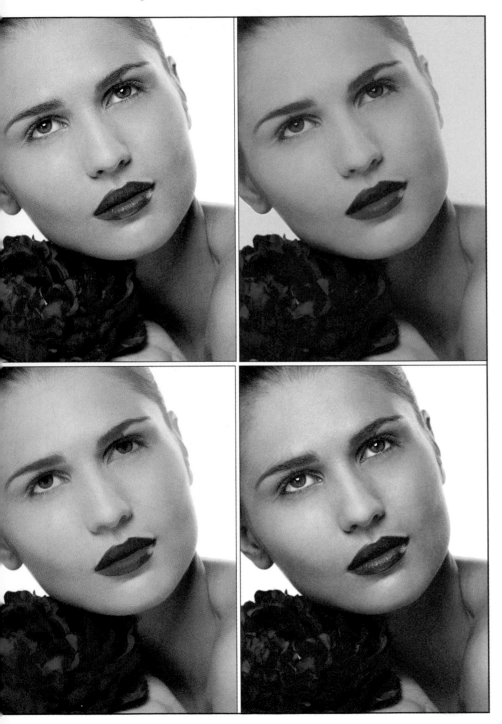

Who says artistic effects have to require lots of Photoshop know-how? They don't. Nor do they require lots of screen time to experiment with adjustments, blending modes and so on. Beautiful artistic effects can be created with a click of your mouse or a tap of your stylus.

The Secret: Use Topaz Simplify from Topaz Labs, available for download from www.topazlabs.com. More info at www.pluginexperience.com.

Topaz Simplify is a relative newcomer to the world of plug-ins, but it's gaining popularity fast because of its ease of use and creative end-results.

With Topaz Simplify, you have two main choices: Presets and Simplify.

With Presets, just click on an effect and it is applied to your image in seconds. Larger files may take longer to apply the effect.

Presets include: Cartoon, Image Crisp Edge, Painting Colorful, Painting Harsh Colorful, Painting Oil, Painting Watercolor (top right image on the opposite page), Sketch Color, Sketch Hard Pencil and Sketch Light Pencil.

Choose Simplify to have total control over the effects, which include detail, saturation, brightness, contrast and edge type.

The bottom left image is the result of reducing detail strength, and the bottom right image was created by increasing saturation.

Check out the subtle differences in these images (e.g., the softness of the model's skin). Often, a subtle change is all you need to create a new artistic version of one of your images.

Enhance Details

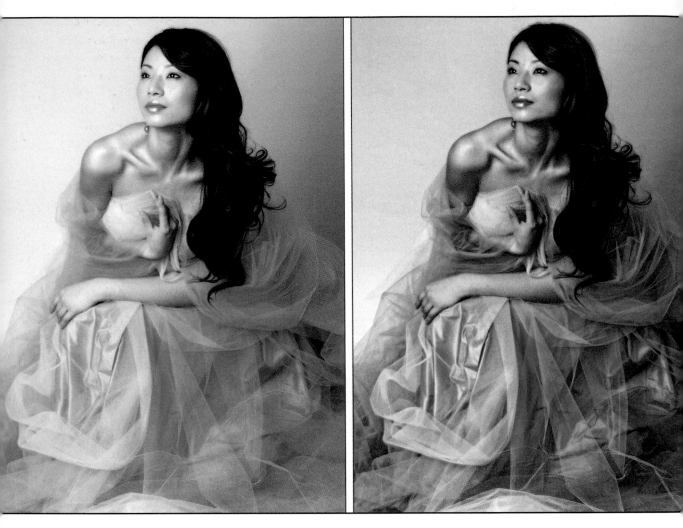

I love the soft-touch effect Vered achieved in the portrait on the left. But check out the digitally enhanced portrait on the right. The details and contrast have been increased, which are most obvious in the model's dress and hair. Notice how the individual hairs are more defined in the edited version.

The Secret: Use Topaz Adjust, a HDR (high dynamic range) plug from the same folks who bring you Topaz Simplify, which is described on the previous page.

As with Topaz Simplify, Topaz Adjust offers several great tools. For enhancing details in an image, I recommend going through the manual tabs, from left to right: Exposure (brightens and darkens), Details (increases details), Color (increases/ decreases color and saturation) and Noise (reduces digital noise).

At the default setting, the Exposure settings show the Adaptive Exposure set at 0 and the Regions set at 4.

To enhance the details in Vered's photograph, the Adaptive Exposure is set to 0.49 and the Regions to 11.

If you boost the detail too much, your photographs will take on a grainy look, which some folks like. Again, play …

Go for a Spin and Blur Reality

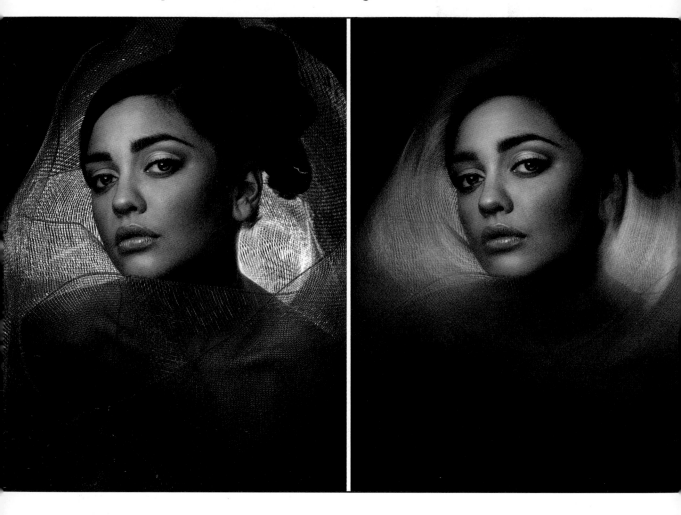

Still portraits—when all the elements of style, composition and lighting come together—can have a striking impact. Sometimes though, adding a sense of motion to a still image can heighten the drama in a picture.

The Secret: Use Photoshop CS4's Radial Blur filter.

Step 1) Go to Filter > Convert for Smart Filters.

Step 2) Go to Blur > Radial Blur. Select Spin and Good. Click in the Blur Center window and place the center point over the center of the subject.

Step 3) In the Layer panel, after you select the Radial Blur filter, you get a mask below the image layer. Click on that mask.

With black selected as the foreground color (in the color picker at the bottom of the Tool Bar), select a soft-edge brush and set the Opacity (on the Options Bar at the top of your monitor) to 100%. Now paint out the blur over the subject's face—only. As you move outward from the face, gradually reduce the Opacity of the brush. The goal is to have a soft transition between the sharp part of your image and the part that is blurred.

Create Movie-Star-Style Lighting

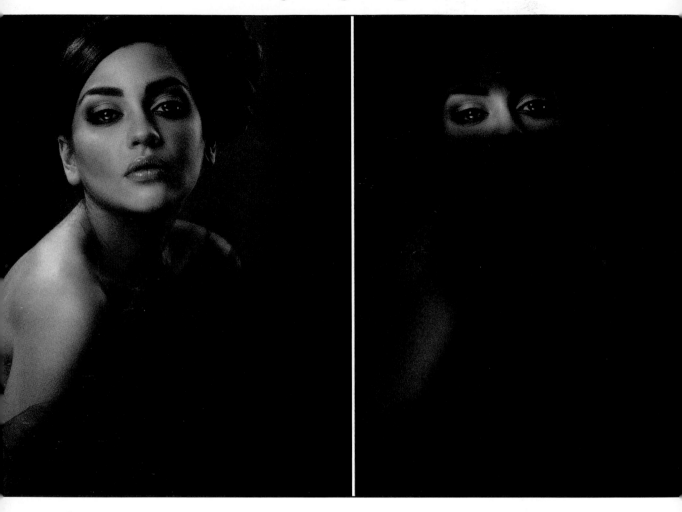

In the 1940s, a trend in still photographs of female movie stars was to create very dramatic lighting that draws attention to their eyes. In those days, photographers used "barn doors" on lights to narrow the beam. This ensured that the light just lit the eyes and the nearby surrounding area of the face. Today, it's much easier to create that effect.

The Secret: Think selectively.

The first step is to duplicate the layer. Now you have two layers exactly the same ... one on top of the other.

On the top layer, first reduce the exposure (Adjustment > Exposure) by about two f/stops. Next, make a selection around the eyes using the Rectangular Marquee tool.

Now press Delete on your keyboard. Doing so reveals the bright area around the eyes on the bottom layer.

Here you see a screen grab of the Layers panel that shows the area around the eyes deleted. It also shows the area around the red material the girl is holding, which I removed, to reveal the brighter material on the bottom layer. This element of the image was removed by using the Eraser tool.

All Together Now

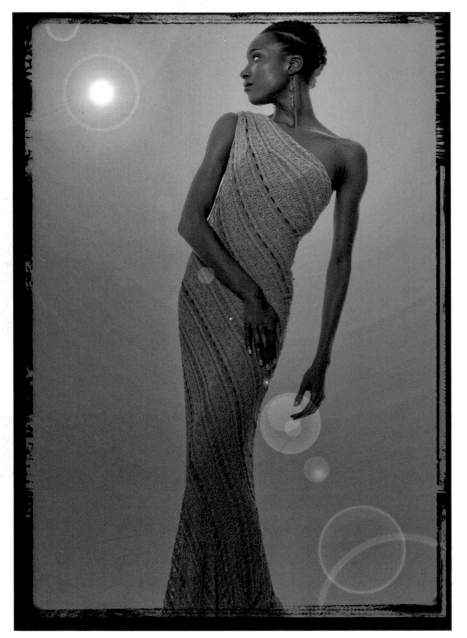

Here we are at the end of this chapter. I hope you learned some new techniques and had a lot of fun.

Before moving on, I'd like to share one more example of how combining filters, plug-ins and effects can create one-of-a-kind images. Here, I used the Lighting Effects filter and the Render Lens Flair Filter (Filter > Render > Lens Flare) and one of the Dave Cross filters in PhotoFrame.

The Secret: Explore and experiment with combinations of post-processing tools to find your unique style.

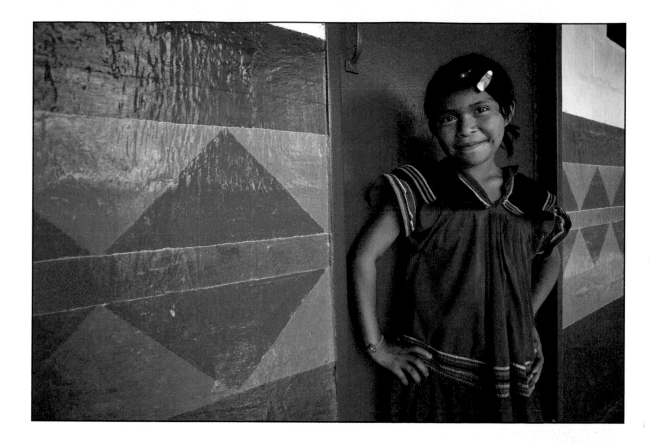

Part XIII

World is my Studio

Vered is the studio pro on this team; I'm the location guy …
although I thoroughly enjoyed working and playing in the studio
during the course of making this book.

In this chapter, I share a few of my favorite travel portraits. Some
were taken in civilized places like Venice, Italy; others were taken
far away from civilization, such as the Brazilian rain forest.

I hope you'll find the inspiration and techniques to take your
work outside the traditional studio environment, too, in order
to find new ways to express your creativity through pictures.

Love, Respect and Seeing

I believe that three things are necessary to capturing a nice portrait—whether in the studio or on location.

One, you have to fall in love … photographically … with your subject. You have to say to yourself, "I must have this person's photograph, and I'll do everything possible to get it."

Two, you must respect the subject; if you don't, (s)he'll feel it in a second. And it'll show.

Three, keep the following saying in mind: *The camera looks both ways; in picturing the subject, you also picture a part of yourself.* In other words, know that the mood, feel, energy and emotion that you project in the photo session will be captured in your subject's face and eyes.

I was thinking about these three things when I photographed these subjects (clockwise form top left) in Panama, Namibia, Cambodia and Kenya.

Envision the End Result

Photography is a two-stage process—after you have the idea for a photograph, that is. These two stages are *image capture* and *image processing*.

With digital imaging, image processing has become more accessible and more important. It has also made it easier to create the image you see in your mind's eye. So the more you know about digital darkroom enhancements, the better off you'll be at envisioning the end result.

When I took this picture in Venice, Italy, I thought about possible enhancements in Photoshop. These enhancements include cropping the image and then selectively increasing the saturation, contrast, detail and sharpness.

Work with Backgrounds

In the professional studio and on location, a background can make or break your shot.

When I'm in the field, I constantly look for backgrounds that will complement a subject. For example, while on assignment in an Embera village in Panama, I noticed an opening between two pieces of material that were hanging in the doorway of a hut. *What a great frame to place around a subject*, I thought. So, for the next hour or so, I asked different members of the village to pose between the material pieces.

The picture above is my favorite shot from that photo session.

Create the Disequilibrium Effect

Tilting the camera down to the left or to the right to create the *disequilibrium effect* is one of the most basic tips in this book. Still, it's worth emphasizing.

The disequilibrium effect adds impact to a photograph because it off-sets the viewer's sense of equilibrium, making the picture a bit more interesting. This technique is applied in the bottom photograph of a young girl in the Gobi of Mongolia.

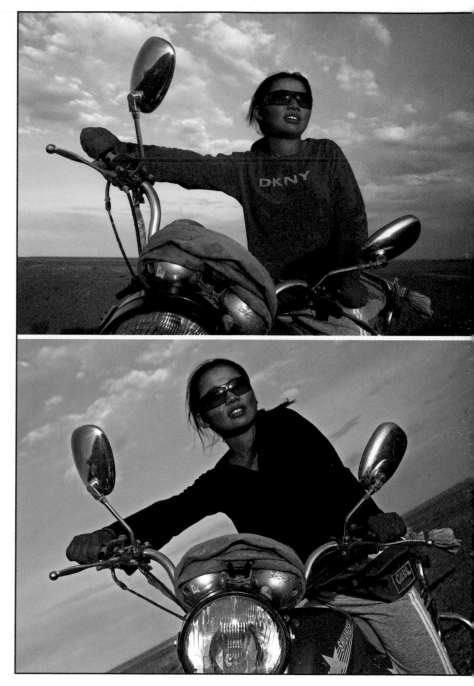

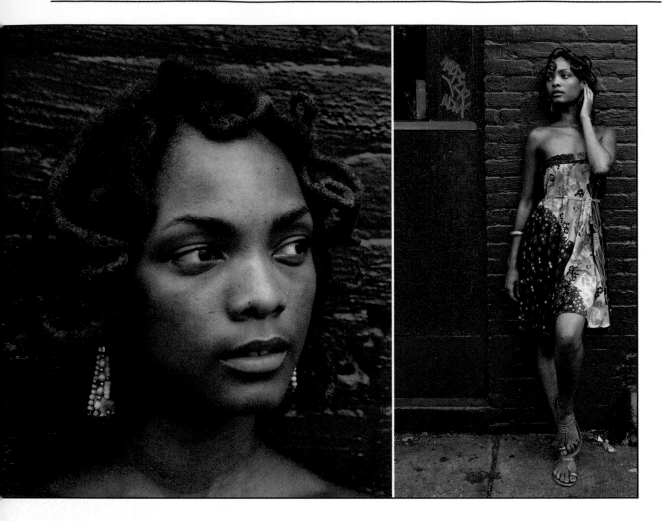

See the Light

Photography is all about seeing the light.

More often than not, lighting in the studio is diffused with an umbrella or a softbox to create a soft and flattering effect. Outdoors, it's also nice to shoot under soft lighting conditions. This means shooting on an overcast day, in the shade, before sunrise or after sunset. You can also create soft lighting outdoors … even on a sunny day … with a diffuser.

These examples are shade shots of a woman I photographed in Little Five Points, Atlanta, Georgia.

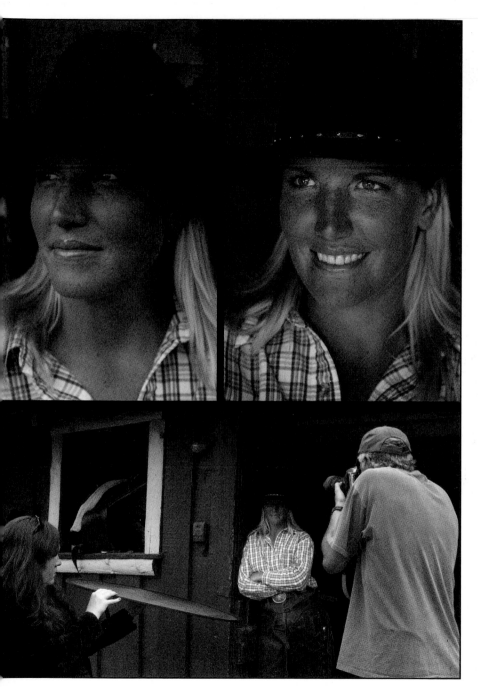

Control the Light with a Reflector

Throughout this book you'll find many examples of controlling the light in the studio. Yet controlling light in the field is important, too.

Here is an example of how controlling light with a reflector brightens a subject's face and adds catch light to her eyes. The gold-color reflector, being held by an assistant, also adds contrast to the scene. Because of its gold color, a warm quality of light is cast on the subject for a warmer, more pleasing effect.

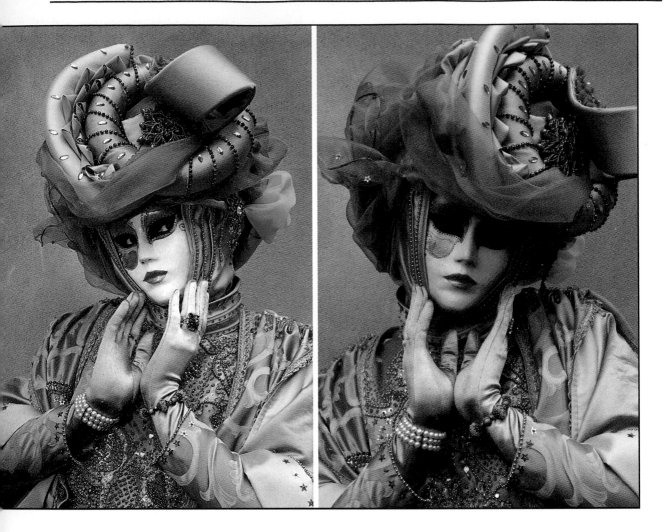

Control the Light with a Flash

On the previous page you read about controlling light with a reflector. Well, another method for controlling light is to use an accessory flash—preferably off camera and triggered by a wireless remote, as this gives you the most creative control.

Compare these two images captured during Carnevale in Venice, Italy.

The picture on the left is a flash shot. Notice how well you can see the eyes in that image, especially compared to the natural-light shot on the right.

The key to using a flash outdoors is to balance the light from the flash to the available light. To do this, set your camera on Manual exposure, dial in the correct exposure, and then reduce the output of your flash until harsh shadows are eliminated.

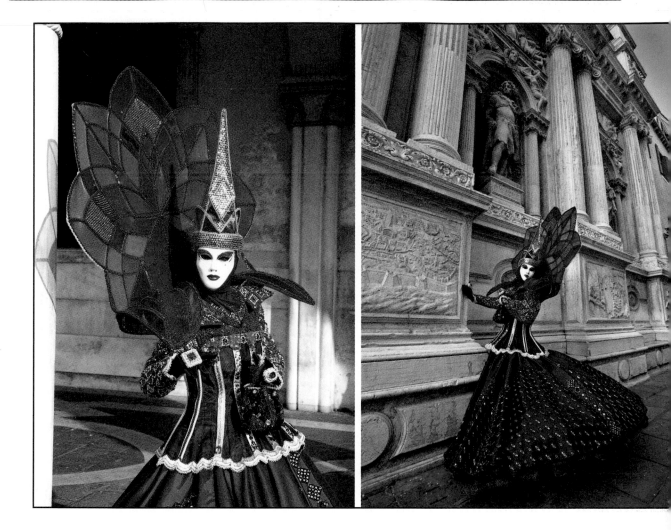

Look for and Create Diffused Light

The picture on the left was taken in bright sunlight. *Yuch* ... The picture on the right was taken in the shade. *Ah, that's more like it.*

When I travel, I love to shoot in the shade, where the contrast range is much lower than in bright daytime sunlight. But if you must shoot under sunny conditions, use a diffuser. Position the diffuser between the sun and your subject to diffuse and soften the light.

An important part of getting a good exposure is seeing the contrast range in a scene and controlling it.

Models, Props and Makeup

You will not find too many "Plain Jane" pictures in this book. One reason is that most of the models have benefited from the work of a professional makeup artist. Another is that cool props were used in many cases.

Props, good makeup and an interesting subject all contribute significantly to the overall quality of a photograph—in a studio and in the field. Never underestimate the importance of these three components.

The photograph on the left was shot during Carnevale in Venice, Italy, and the photograph of the woman on the right was taken deep within the Brazilian rainforest.

Make Pictures

Every studio photograph you see in this book is the result of *making* a picture … versus the more passive point-and-click process of *taking* a photograph.

In the field, I usually make pictures, which involves directing a subject. Here are two of my favorite examples.

The top photograph was made in Mongolia after asking the monk and the woman to move close to the wall in the background and then to stand relatively close together.

The bottom photograph was made in Panama after asking the little girl to lean against the wall and to look off camera.

Making pictures is fun … in the studio and on location.

Meter Your Exposures

Sure, you can save an exposure that's not perfect by adjusting it on in Photoshop (to a degree). But it's much better to get a good in-camera exposure. Easier said than done in some cases …

For instance, here are two situations that can fool a camera's light meter into setting the wrong exposure for the subject.

In the photograph on the left, which was shot during one of my workshops in Salem, Massachusetts, bright light coming through the car's windows could have resulted in an underexposed subject.

In the picture on the right, taken in Bhutan, the dark background could have resulted in an overexposed subject.

To avoid mis-exposure when you have a background that is darker or brighter than your subject, be sure to use the spot meter feature in your camera. Set the exposure for the subject.

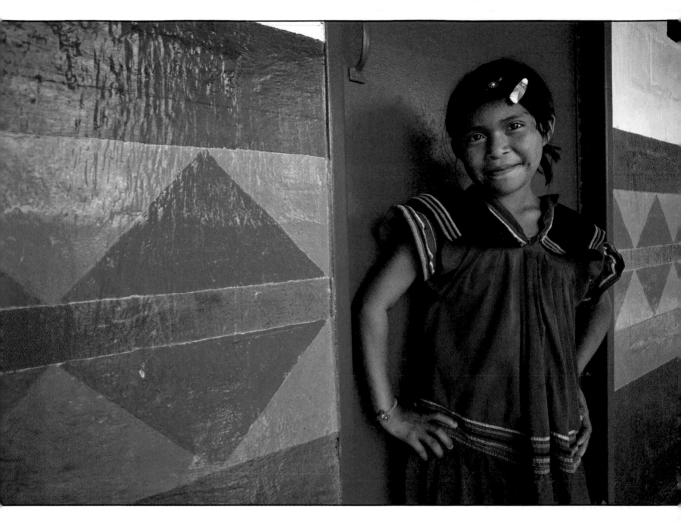

Work with Colors

Wow! Look at the vibrant colors in this photograph shot in Panama.

Sure, the colors in the scene were there, but I enhanced them in Photoshop by boosting the saturation of the image.

When you are out in the field, look for colorful subjects and vibrant backgrounds. Put them together and you'll have a photograph that "pops."

Check out some of the studio shots in this book. The colorful props and makeup help to make those photographs pop, too.

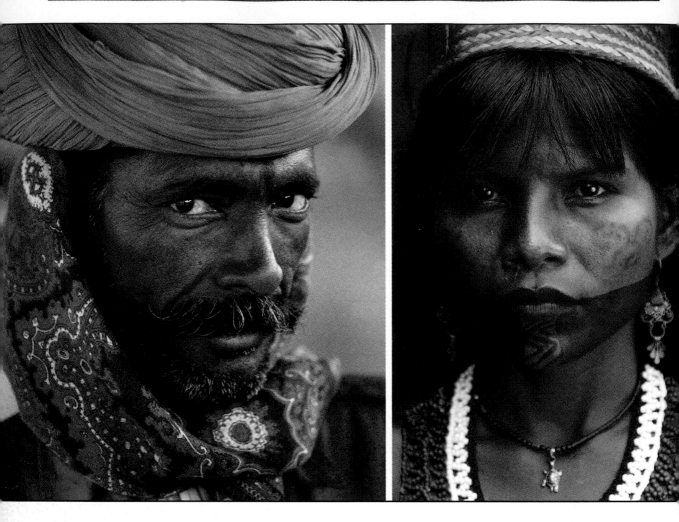

The Eyes Have It

The eyes are the windows to the soul is perhaps the best-known photographic expression. It's true; eyes do reveal a subject's feelings. That's why it's essential that you pay close attention to what the subject's eyes are "saying," which can change from second to second.

Light the eyes, as shown here, using a reflector. The image on the right was shot in India and the one on the left was taken in Panama; both were illuminated with a reflector.

Paying People

This is my very first travel portrait. It was taken in Hong Kong in 1975.

With his finger, the man is saying, "Pay me one more dollar."

See, seconds before, I had taken a picture of him, for which he had charged me one dollar. When I went to take a second picture, his raised his hand and I took this shot. From that moment on, I have gladly paid adults in foreign countries for their pictures, just like I pay models here in the U.S. As long as I am getting a photograph that I can use, I believe that payment is in order.

However, I never pay children, as that promotes begging. When I do photograph children though, I ask my guide how I can make a donation to a local school or charity.

By the way, I only use my travel photographs for editorial work and not for advertising. If I sold them for marketing uses, I'd need a signed model release.

Play with Plug-ins

I encourage you to play with plug-ins, as they can truly help you to awaken the artist within. Here is the effect of applying the Bleach Bypass filter in Nik Color Efex Pro to a photograph of a woman in Namibia.

For more plug-in information (and to get special discounts), check out the web site I started for plug-in users: Plug-in Experience (www.pluginexperience.com). And if you have a good example of a plug-in effect, send it to me though that site.

HDR Plug-in Effects

HDR (High Dynamic Range) photography is the latest and greatest trend in photography. Most often, it's used to create landscape, seascape and cityscape images—from three or more images (with different exposures). For some real photo fun … and creative showmanship … try creating an HDR image from one image.

You'll need to use Topaz Adjust (www.topazlabs.com) or LucisArt (www.lucisart.com), which is the plug-in I used to create this HDR image of a man I photographed in Cuba.

Look at the difference in his eyes and in the detail of the entire image. After I created the HDR image, I cropped and tilted the picture to create the disequilibrium effect.

Working with Mirrors

Wedding photographers love to use mirrors when they photograph brides in their homes. When I travel, I like to use mirrors, too.

When working with mirrors, it's important to look for everything that is reflected in the mirror. In most cases, the last thing you want to see in your final image is yourself. Avoid that by shooting at an angle.

Balancing the light in the reflected image and in the foreground can also be tricky. For the top image, which I took in Panama, an assistant held a reflector to camera left to bounce the light from an open window on the right onto the man's face. In the bottom image, which I took in Texas, I lit the room in the background with strobes to create a strong silhouette of the cowboy standing in the doorway.

Shooting Profiles and Silhouettes

Two elements are important when photographing profiles and silhouettes:

1) Subject Position: The subject must be facing directly left or right.

2) Background Lighting: If your background is darker than the subject (as in my picture of a Maasai woman on the left), you'll get a nice profile. If the background is brighter than your subject (as in my picture of a young Mongolian woman on the right), you'll create a nice silhouette.

Draw More Attention to the Subject

Obviously, these are all similar photographs of a Namibian woman and her child; left and middle are the same image. However, the image in the middle has more impact than the image on the left, and the image on the right has more impact than the image in the middle. Why?

In the middle image, I darkened the edges of my original image to draw more attention to the main subject. For the image on the right, I simply zoomed in closer to the subject.

Try these two techniques to draw more attention to your subject. And remember that the closer you get to a subject, the more intimate the photograph becomes.

Why Off-Center Composition Works

These two photographs—one of a cowboy in Texas and one of the "Official Park Man in Cuba"—illustrate how the off-center composition technique can make an image more interesting.

See, when you place your subject off-center, the viewer's eyes look around the frame to see what else is in the scene. More of a story is captured. But when the subject is placed dead center in the frame, the viewer's eyes get stuck on the subject and interest usually fades quickly.

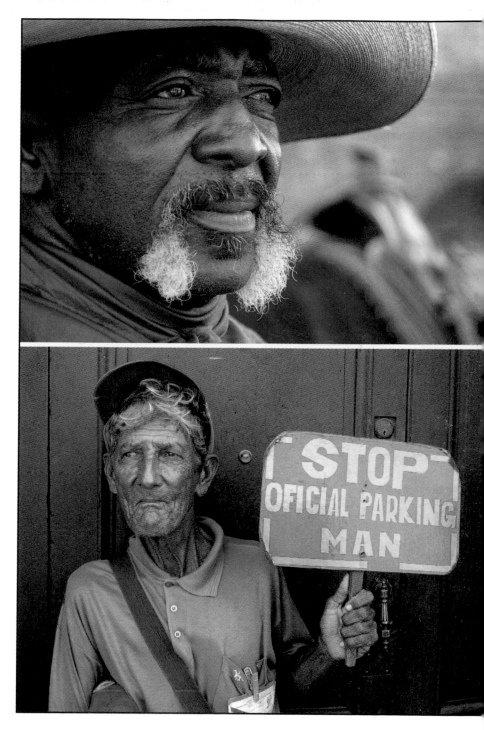

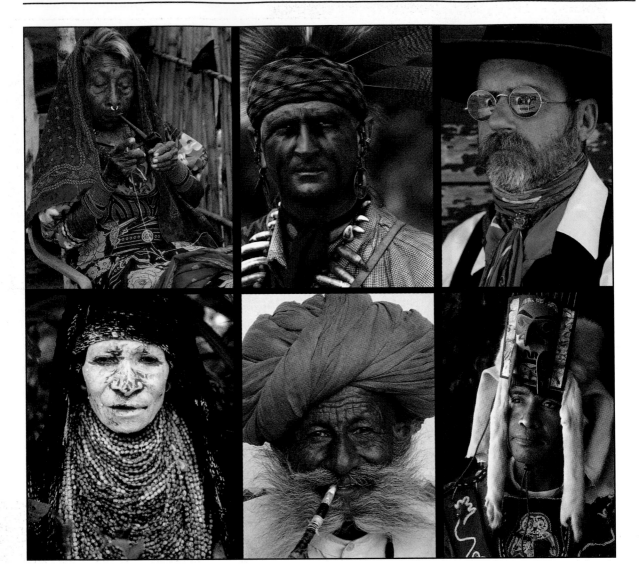

Don't Underestimate the Importance of an Interesting Subject

These pictures have something in common: an interesting subject. Never underestimate (or "mis-underestimate" … as one of our former presidents used to say) the importance of a good subject. For me, it's one of the most important elements of a good photograph.

What makes an interesting subject? Well, that decision is up to you—and your audience.

Part XIV

Cool Websites for Flash Info

In the fast-paced, ever-changing world of studio lighting and people photography, it can be tough to stay up-to-speed with the latest and greatest in gear and accessories. Fortunately, the Internet can help by making information and products easily accessible. On the following pages are websites I use to stay current. Log on and check 'em out!

Strobist

www.strobist.blogspot.com

This website, created by Dave Hobby, is the mother source for learning how to use off-camera flash with your dSLR to take your photos to the next level … or the next ten levels!

Here, you'll find everything you need to know about how to best use your small speedlights. There are more than a thousand articles about lighting. More than two million photographers from around the world have learned small-flash lighting techniques from this site. We're thinking you can, too.

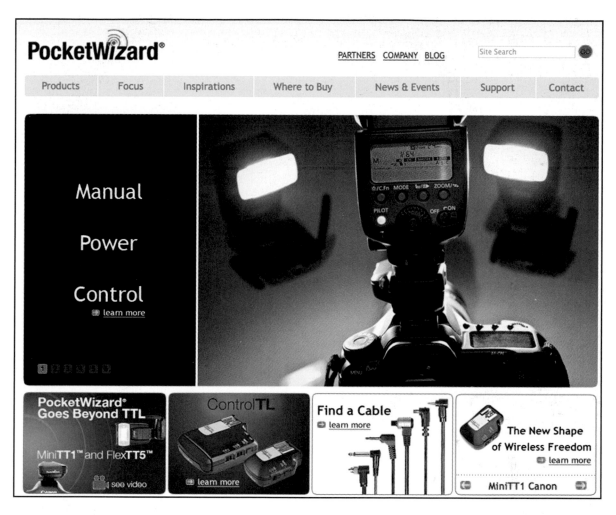

PocketWizard

www.pocketwizard.com/

Whether you're firing a remote camera mounted on an airplane wing, using TTL flash for a wedding, or working a fashion shoot with Manual Power Control, PocketWizard's wireless triggering systems make it possible.

Now with E-TTL II and Manual Power Control capability, the new MiniTT1 and FlexTT5 radio slaves, featuring ControlTL, make taking off-camera flash photos nearly effortless. Just slide-in, turn-on and shoot. For more information on using PocketWizard wireless tools, take a look at Chapter 9: Unleash Yourself.

Westcott

www.fjwestcott.com

Got light? Need light? Virtually all your lighting and portrait photography needs (including backgrounds) can be met on this site. That goes for professional photographers as well as those who are just starting out.

Two "must-see" pages are the Community Gallery and the Discussion Boards. Hey, participate! Share, learn and enjoy.

LumiQuest

www.lumiquest.com

LumiQuest offers an incredible range of diffusers and light modifiers that attach to camera flash units quickly and easily with Velcro. The idea: Soften the light for a more pleasing and flattering effect. Some units even come with filters to modify the color of the light from the flash.

Back to Back

www.backtobackdesignworks.com

Want to create the impression that a subject was photographed on a professional movie set or in a totally cool location? That's easy with one of the dozens of Back to Back sets. These sets assemble in minutes and can be used in a medium-size studio/ room as well as in your backyard and on location. If you are a full-time studio pro and take your work seriously, then seriously consider using these professional sets.

Canon Digital Learning Center

www.usa.canon.com/dlc

Sure, if you use Canon cameras and printers, this site offers tons of information—articles, videos and interviews—that will help you get the most out of your gear and awaken the artist within.

Even if you use another brand of camera or printer, there is still lots to learn on this site. Many of the articles (including mine on the EOS Digital Rebel) include general photography information.

While you are on the site, click on the link to the Explorers of Light and Print Masters. I'm sure you'll be impressed by the photographs of some of the top image makers in the world today … from all photographic specialties.

Bogen Imaging

www.bogenimaging.com/

Bogen Imaging Inc. was originally established as Bogen Photo in the 1950s and is the cornerstone of the international network of Bogen Imaging companies in the USA, France, Germany, Italy, Japan and the U.K. The company imports, distributes and services accessory products in the photographic, video, broadcast and lighting imaging sectors.

All the brands have a global reputation for design, innovation and quality and are the first choice of many of the world's leading professional image takers:

- Gitzo has been the professional's first choice for photographic tripods and is now the first choice of the serious enthusiast.

- Manfrotto produces the most extensive range of camera tripods, lighting stands and accessories that are used by more professionals than any other brand in the key sectors we've addressed.

- Kata bags offer the ultimate protective bags that are lightweight and designed for a digital world … be it photographic or high-end video.

- *National Geographic* selected Manfrotto and Kata to design an advanced line of innovative tripod and bags that have the prestigious National Geographic branding.

- Avenger-grip equipment, lighting stands and accessories are used by more professionals than any other brand in the key sectors we addressed.

- Other Brands: Bogen Imaging is the exclusive U.S. distributor for a number of additional brands that serve the video, photographic, lighting and related markets. You can see them all on the home page.

Lexar

www.lexar.com

Before you check out the write speed of these cards and the other tech info on this site, take a look at these pages: Pro Photographer Corner, Workflow and Technology, Tips + Lessons, Photo Gallery and Pro Articles.

After you have absorbed all the great info on those pages, explore the tech talk. You'll be impressed with the cards … and with the pros that use 'em.

Kelby Training

www.kelbytraining.com

Scott Kelby, Dave Cross, Moose Peterson, Vince Versache, Joe McNally, Eddie Tapp, Ben Wilmore and John Paul Caponigro (plus yours truly) are just a few of the instructors who share their photography and Photoshop know-how with you on this site.

Sign up for a month or a year; it's up to you. I guarantee that you will learn a ton from each and every class.

For starters, take the Tour. Then check out a few previews.

New instructors are always being added, so check back from time to time for more photo and Photoshop tips.

Honl Photo

www.honlphoto.com

The Honl Photo Speed System is a collection of lightweight, durable and affordable light modifiers for shoe-mount flash. Designed to universally fit all shoe-mount flashes, the versatile light modifiers from Honl Photo provide photographers with an assortment of practical tools to shape light without resorting to cumbersome, heavy and expensive lighting equipment.

The Honl Speed System was devised by photojournalist David Honl. It consists of an assortment of grids, snoots, gobos and gels that attach quickly and easily to any shoe-mount flash via the Speed Strap—a simple, non-slip Velcro strap that wraps around the flash head without the use of annoying adhesives. The Honl Photo Speed System allows you to bring studio-style lighting control with you into the field.

Rick Sammon

www.ricksammon.com

I thought I'd close this chapter with my favorite website: mine!

Seriously, I do spend a lot of time on my site, updating it with new—and free—how-to articles, schedules for my seminars and workshops, and cool links. While browsing my site, you'll also see a few of my favorite images and several of my YouTube videos.

If you have been to one of my workshops (or plan to attend one soon), be sure to check out a page of photos from my workshop participants. Don't be shy about sending me images for this page. Email low-res files (72 PPI, 5x7, JPEG) to me at ricksammon@mac.com.

Also, follow me on Twitter: www.twitter.com/ricksammon.

Rick Sammon's Basic Lighting and Portraiture DVD

What you'll see and how to see it!

What a deal! The DVD enclosed with *Studio and Location Lighting Secrets for Digital Photographers* includes 11 QuickTime movies that reinforce (and add to) the tips and tricks you've learned throughout this book.

I had a ton of fun producing these info-packed, live-action video lessons listed below.

As far a viewing them, that's easy! Simply pop the DVD into your DVD drive on your computer (not into your home DVD players). Click on a movie and away you go. Use the arrows and buttons on the bottom of the QuickTime window to play, stop, fast-forward and rewind the movies.

Enjoy! If you like what you see, check out these DVDs and my other DVDs on amazon.com.

Wiley Publishing, Inc.
End-User License Agreement

READ THIS. You should carefully read these terms and conditions before opening the software packet(s) included with this book "Book". This is a license agreement "Agreement" between you and Wiley Publishing, Inc. "WPI". By opening the accompanying software packet(s), you acknowledge that you have read and accept the following terms and conditions. If you do not agree and do not want to be bound by such terms and conditions, promptly return the Book and the unopened software packet(s) to the place you obtained them for a full refund.

1. **License Grant.** WPI grants to you (either an individual or entity) a nonexclusive license to use one copy of the enclosed software program(s) (collectively, the "Software," solely for your own personal or business purposes on a single computer (whether a standard computer or a workstation component of a multi-user network). The Software is in use on a computer when it is loaded into temporary memory (RAM) or installed into permanent memory (hard disk, CD-ROM, or other storage device). WPI reserves all rights not expressly granted herein.

2. **Ownership.** WPI is the owner of all right, title, and interest, including copyright, in and to the compilation of the Software recorded on the disk(s), CD-ROM or DVD "Software Media". Copyright to the individual programs recorded on the Software Media is owned by the author or other authorized copyright owner of each program. Ownership of the Software and all proprietary rights relating thereto remain with WPI and its licensers.

3. **Restrictions On Use and Transfer.**
 (a) You may only (i) make one copy of the Software for backup or archival purposes, or (ii) transfer the Software to a single hard disk, provided that you keep the original for backup or archival purposes. You may not (i) rent or lease the Software, (ii) copy or reproduce the Software through a LAN or other network system or through any computer subscriber system or bulletin-board system, or (iii) modify, adapt, or create derivative works based on the Software.

 (b) You may not reverse engineer, decompile, or disassemble the Software. You may transfer the Software and user documentation on a permanent basis, provided that the transferee agrees to accept the terms and conditions of this Agreement and you retain no copies. If the Software is an update or has been updated, any transfer must include the most recent update and all prior versions.

4. **Restrictions on Use of Individual Programs.** You must follow the individual requirements and restrictions detailed for each individual program in the About the DVD appendix of this Book. These limitations are also contained in the individual license agreements recorded on the Software Media. These limitations may include a requirement that after using the program for a specified period of time, the user must pay a registration fee or discontinue use. By opening the Software packet(s), you will be agreeing to abide by the licenses and restrictions for these individual programs that are detailed in the About the DVD appendix and on the Software Media. None of the material on this Software Media or listed in this Book may ever be redistributed, in original or modified form, for commercial purposes.

5. Limited Warranty.

(a) WPI warrants that the Software and Software Media are free from defects in materials and workmanship under normal use for a period of sixty (60) days from the date of purchase of this Book. If WPI receives notification within the warranty period of defects in materials or workmanship, WPI will replace the defective Software Media.

(b) WPI AND THE AUTHOR(S) OF THE BOOK DISCLAIM ALL OTHER WARRANTIES, EXPRESS OR IMPLIED, INCLUDING WITHOUT LIMITATION IMPLIED WARRANTIES OF MERCHANTABILITY AND FITNESS FOR A PARTICULAR PURPOSE, WITH RESPECT TO THE SOFTWARE, THE PROGRAMS, THE SOURCE CODE CONTAINED THEREIN, AND/OR THE TECHNIQUES DESCRIBED IN THIS BOOK. WPI DOES NOT WARRANT THAT THE FUNCTIONS CONTAINED IN THE SOFTWARE WILL MEET YOUR REQUIREMENTS OR THAT THE OPERATION OF THE SOFTWARE WILL BE ERROR FREE.

(c) This limited warranty gives you specific legal rights, and you may have other rights that vary from jurisdiction to jurisdiction.

6. Remedies.

(a) WPI's entire liability and your exclusive remedy for defects in materials and workmanship shall be limited to replacement of the Software Media, which may be returned to WPI with a copy of your receipt at the following address: Software Media Fulfillment Department, Attn.: Studio and Location Lighting Secrets, Wiley Publishing, Inc., 10475 Crosspoint Blvd., Indianapolis, IN 46256, or call 1-800-762-2974. Please allow four to six weeks for delivery. This Limited Warranty is void if failure of the Software Media has resulted from accident, abuse, or misapplication. Any replacement Software Media will be warranted for the remainder of the original warranty period or thirty (30) days, whichever is longer.

(b) In no event shall WPI or the author be liable for any damages whatsoever (including without limitation damages for loss of business profits, business interruption, loss of business information, or any other pecuniary loss) arising from the use of or inability to use the Book or the Software, even if WPI has been advised of the possibility of such damages.

(c) Because some jurisdictions do not allow the exclusion or limitation of liability for consequential or incidental damages, the above limitation or exclusion may not apply to you.

7. U.S. Government Restricted Rights. Use, duplication, or disclosure of the Software for or on behalf of the United States of America, its agencies and/or instrumentalities "U.S. Government" is subject to restrictions as stated in paragraph (c)(1)(ii) of the Rights in Technical Data and Computer Software clause of DFARS 252.227-7013, or subparagraphs (c) (1) and (2) of the Commercial Computer Software - Restricted Rights clause at FAR 52.227-19, and in similar clauses in the NASA FAR supplement, as applicable.

8. General. This Agreement constitutes the entire understanding of the parties and revokes and supersedes all prior agreements, oral or written, between them and may not be modified or amended except in a writing signed by both parties hereto that specifically refers to this Agreement. This Agreement shall take precedence over any other documents that may be in conflict herewith. If any one or more provisions contained in this Agreement are held by any court or tribunal to be invalid, illegal, or otherwise unenforceable, each and every other provision shall remain in full force and effect.

Index